Solace

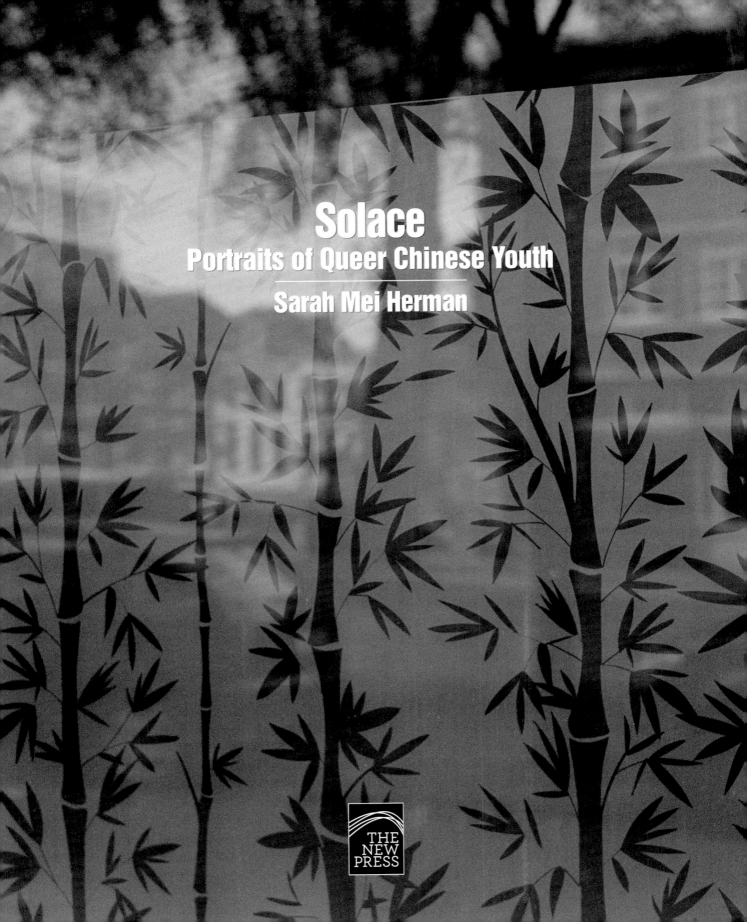

Solace
Portraits of Queer Chinese Youth

Sarah Mei Herman

THE NEW PRESS

No part of this book may be reproduced, in any form, without written permission from the publisher.
Requests for permission to reproduce selections from this book should be made through our website:
https://thenewpress.com/contact.

Published in the United States by The New Press, New York, 2022
Distributed by Two Rivers Distribution

ISBN 978-1-62079-632-6 (pb)
ISBN 978-1-62097-633-3 (ebook)
CIP data is available

The New Press publishes books that promote and enrich public discussion and understanding of the issues vital to our democracy and to a more equitable world. These books are made possible by the enthusiasm of our readers; the support of a committed group of donors, large and small; the collaboration of our many partners in the independent media and the not-for-profit sector; booksellers, who often hand-sell New Press books; librarians; and above all by our authors.

www.thenewpress.com

Book design and composition © 2022 by Emerson, Wajdowicz Studios (EWS)
This book was set in Helvetica Inserat, Helvetica Neue, FF Meta Pro, Source Han Sans CN, and News Gothic BT.
Printed in the United States of America

10 9 8 7 6 5 4 3 2 1

Preface
JON STRYKER

This project was born out of conversations that I had with Jurek Wajdowicz. He is an accomplished art photographer and frequent collaborator of mine, and I am a lover of and collector of photography. I owe a great debt to Jurek and his design partner, Lisa LaRochelle, for bringing this book series to life.

Both Jurek and I have been extremely active in social justice causes—I as an activist and philanthropist and he as a creative collaborator with some of the household names in social change. Together we set out with an ambitious goal to explore and illuminate the most intimate and personal dimensions of self still too often treated as taboo: sexual orientation and gender identity and expression. These books continue to reveal the amazing multiplicity in these core aspects of our being, played out against a vast array of distinct and varied cultures and customs from around the world.

Photography is a powerful medium for communication that can transform our understanding and awareness of the world we live in. We believe the photographs in this series will forever alter our perceptions of the arbitrary boundaries that we draw between others and ourselves and, at the same time, delight us with the broad spectrum of possibility for how we live our lives and love one another.

We are honored to have Sarah Mei Herman as a collaborator in *Solace*. She and the other photographers in this ongoing series are more than craftspeople: they are communicators, translators, and facilitators of the kind of exchange that we hope will eventually allow all the world's people to live in greater harmony. 卐

Jon Stryker, philanthropist, architect, and photography devotee, is the founder and board president of the Arcus Foundation, a global foundation promoting respect for diversity among peoples and in nature.

Introduction

CHEN CHEN

What a delight, a gorgeous gift to get to write this introduction for *Solace: Portraits of Queer Chinese Youth* by Sarah Mei Herman. This is a book I wish existed when I was younger, when I was thirteen and knew that I was gay and started to come out of the closet. This is a book I needed when I was fourteen and forced myself back into the closet out of fear—terror that I would not find love or acceptance, any viable path in life, any future. This is a book I would have embraced at fifteen, sixteen, when I again came out.

This book is one I am so glad to have and to embrace now, at thirty-three, continuing to navigate a straight world that pushes queer people into closets of all kinds. I now understand that the closet is not my invention but a condition of societies that would rather I disappear than claim or make any space of my own. These days I am less interested in straight acceptance or rejection, in others' ways of defining or erasing my personhood.

What I am interested in: the lives, the imaginations, the interiorities of my fellow queer people, especially those whose queerness also intersects with Chineseness. And I am invested in expansiveness when it comes to both categories—how queerness and Chineseness can be whole universes, multiverses that continue to branch and grow.

I refuse to see queer Chinese worlds as narrow, as too "specific" a subject to write about or photograph. I am thrilled to see how Herman seems to agree with her beautiful work in this book—these photos encourage a kind of seeing that is richly layered, playful, soft, and immensely caring. Softness lives here, yes, but it demands true engagement. These photos radiate a gentleness that I experience as a form of strength. Their range of emotion astonishes: joyful, desirous, melancholic, whimsical, yearnful, loving, contemplative, nervous yet utterly present, tired but not defeated.

These photos brim with warmth, at once intimately domestic and boldly declarative. Each image declares, *here I am* or *here we are*. Each is a tender cosmos, uncompromising in its textured humanity and complete in its own way—while also suggesting a vast aliveness shimmering outside the frame.

For this introduction I would like to highlight just two images in particular (though all of them speak to and resonate with me in ways I will keep ruminating on for a long, long time). The two images are: Chen Ze on pages 18–19 and then Cai Zhemin and Lai Xiaoli on pages 14–15. In both of these photos, a window figures prominently in the composition and atmosphere; how the subjects are positioned in relation to the window—a site/sight of possibility, of daydreaming, of dreaming toward some abundant thing one longs for—moves me and kindles my imagination.

First, Chen Ze on pages 18–19: I love how he is sitting in a window ledge, in front of a very large window, bright natural light streaming in but gently, such that he can sit comfortably in partial shade. I love his relaxed attire and posture, his feet left bare, his arms lightly crossed and resting on his knees, his hands hanging in a carefree way. At the same time, his gaze feels defiant, casually defiant, his eyes meeting the camera with a charismatic determination. He is cool and seems to know it, though not in any overbearing manner. His determination doesn't look cold or cynical; rather, his expression is one of simple confidence and clarity.

My sense is that he knows what he wants, or the main and important things anyway, and he will pursue them; he is pursuing. Chen Ze's gaze is not directed toward the window but to the camera, the photographer, the eventual viewer/reader of this book. The window may represent the world, a horizon of possibility, but he seems more interested in engaging another person. He seems on the verge of speaking. He has something to share with us, perhaps something in the window we have not noticed ourselves. He is ready to point it out.

Next, Cai Zhemin and Lai Xiaoli on pages 14–15: these two appear to be a couple, based on how closely they are standing—not next to each other but with each other, one's head leaning in and slightly resting on other's cheek. They, too, are in front of a window, though their relationship to it is altogether different from Chen Ze's to his window. Here the pair is looking in different directions, seemingly lost in their individual thoughts, though still intimately connected. The photo makes me think of me and my own partner, in our day-to-day working lives, where often we are in different spaces, engaged with different goals and responsibilities, yet still considering each other with every move. Or: we are both at home, just in different rooms. Or: we are both in the kitchen, say, and leaning in, touching a cheek, a shoulder, while thinking about and looking at different things.

The way Cai Zhemin and Lai Xiaoli are looking at different things in this photo reminds me of so many small, quotidian and yet exquisite moments from life as a couple. They may very well be thinking of the same thing but in divergent, idiosyncratic modes; they may be thinking of each other like that. One seems to be looking out the window, her face

bathed in soft golden light. Meanwhile her partner is looking off to the side and slightly downward, half her face in shadow, the other half also in that warm, warm gold.

Unlike what I saw in the image of Chen Ze sitting in a window ledge, the subjects here don't seem ready to talk to an outside audience. They are immersed in their own worlds—individually and also as a pair. Neither is looking into the camera, into a photographer's or viewer's gaze. Instead, they stand engaged with their own interiorities. The window is a site where they get to fall into slow, careful contemplation. A sense of determination may reside here, too, in the shunning of the camera's presence, in the one's window gazing and the other's more inward expression. In any case, I am so moved by the photo's focus—not only does a queer couple get to be the star here but they get to exist in their own universe, for themselves. Their queerness and Chineseness need no explanation, especially not to a non-queer, non-Chinese audience. Whether they are "out" in any larger, public way does not matter. What matters, in this portrait, is how much space they have, how free they are to think and feel and want what they want.

And their thoughts, feelings, and wants in this photographed moment might be about larger, societal acceptance of LGBTQ people. I don't know. In writing about these images, these words are, of course, my subjective interpretations. I could be wrong about what's happening in the photos, in the subjects' hearts and innermost chambers. But I am grateful for this opportunity to imagine, to let my imagination roam, gallop, sprawl out in response to this art and to let myself be transformed by its power.

What I feel completely confident in asserting is that these images were created by a photographer who cares about her subjects as people. And that care leads to my dreaming, my interpreting these images in the ways I do. There's a spaciousness here where both subject and viewer are respected; I don't feel as though I'm being spoon-fed a reductive "message" about queer Chinese youth and their lives. I feel enlivened, empowered to "read" these photos in an exciting variety of ways.

I am writing this introduction in May 2022, with Pride month in the United States right around the corner. Increasingly each year, around this time, I feel a sense of dread rather than excitement. I still enjoy many aspects of Pride month, especially those related to queer poetry and poets. But I am disturbed by how commodified and corporatized some parades and celebrations have become. Pride began as a protest, a riot, a refusal to assimilate into straight, mainstream norms and values. I get angry over statements like "we're just like you" that seem to beg for mainstream acceptance and capitalist power. Why should we, as queer people, strive for that? We can accept ourselves and each other—let us celebrate the power in that.

Perhaps that is one meaning behind Herman's title for this book, *Solace*—all the resourceful, inventive, playful ways in which LGBTQ people find and build community with one another. It's a form of solace in a world that too often denies us basic comforts and support. We have each other. And those lacking community can take some comfort in this very book, in these images of love and community as well as of solitude and yes, loneliness— but a kind of loneliness that doesn't have to be crushing. Of course, grief and sorrow are a part of queer lives, too, and I love how this book doesn't

shy away from those intensities; it reflects those emotions while seeming to say: tragedy doesn't have to define queer life.

Looking and looking at these images, I can't help but think of the late, great June Jordan and the title of her collected poems: *Directed by Desire*. The subjects of these photos appear to be deeply directed by their own desires: to learn about and understand themselves, to forge connections, to tend to their loves, to reimagine relationship structures, to love themselves more fully, to fight for societal change and social justice, to make out of their lives freshness, tenderness, good surprise, queer joy, alternate ways and spaces in which to not only survive but thrive.

It would be remiss of me not to mention the fact that this book has a particular focus on young people from Xiamen, a city in southern China that typically doesn't get much international media attention—and my birthplace. My immediate family emigrated to the United States when I was just about four, but I still have extended family in Xiamen and have visited them. I've long wondered if I would/could ever come out to them.

For a while I thought it unnecessary since I'm not very close with my relatives and don't get to see them often. Lately, though, I've been rethinking this framing—what if I could become closer with them, by sharing more of my actual life? What if I learned that I had a bi cousin, a trans uncle, a lesbian niece? How else might my queer Chinese multiverse expand?

My use of the term "multiverse" is in part inspired by the 2022 film *Everything Everywhere All at Once* (A24, directed by Daniel Kwan and Daniel Sheinert), another piece of art and culture that I wish existed when I was younger and am so happy exists now.

When I first came out to my parents, they denied it completely. They thought it an impossibility—gay *and* Chinese? They didn't have any examples of this being a kind of person to be. Thus, I was no longer a real person in their eyes. "This doesn't happen in China," they said, over and over, to the point where a part of me believed their absurd claim. I must be an anomaly, I thought. A subcategory of freak within the realm of freaks.

For years I sought out acceptance and community among non-Chinese queer people. I am still in a process of unlearning the separation between my queerness and Chineseness. I am learning how to bring every part of myself, every world-self and self-world, together. And now I have *Everything Everywhere*, I have *Solace*, and many other queer Chinese texts, artworks, sources of nourishment and magic, vessels of desire and direction.

This photobook reminds me: I have my own art, too, as solace and sustenance. So, because I am a poet primarily and in my marrow, let me close with a poem, one that I wrote to celebrate being a queer Chinese multiversal proud freaky phenomenon. 🏮

Little Song

I am sitting in the grass I hear a microwave from the house Someone setting the time

Then changing their mind Little song of beeps The bees come to visit the hydrangeas

They're a loopy lopsided equation that actually works out that is the foundation

of the universe The bees decide to visit me I try to stay still so they can visit properly

& am returned to my body the squishy cantaloupe depths the memory of when I was a kid

the days of excitement over the phrase "centrifugal force" I think it was my #1 phrase

for a week I started telling people that was where babies came from My father the scholar

shook his head & explained capital N- Nature yin & yang *You must have opposites* he said

For years I thought gay people didn't exist in China But then I went to a nightclub

in Shanghai small & literally underground but packed with gorgeous men Chinese men

a winding techno garden of them Only women my straight friend & the hardworking old lady

at coat check I danced till I got sweaty then too sweaty In the rest area a man passed by

& pinched my nipple through my now see-through shirt I saw how China could be

& Nature could & me singing in the grass little songs about gravity

from Chen Chen, *When I Grow Up I Want to Be a List of Further Possibilities*, BOA Editions, 2017.
Reprinted with permission of the author.

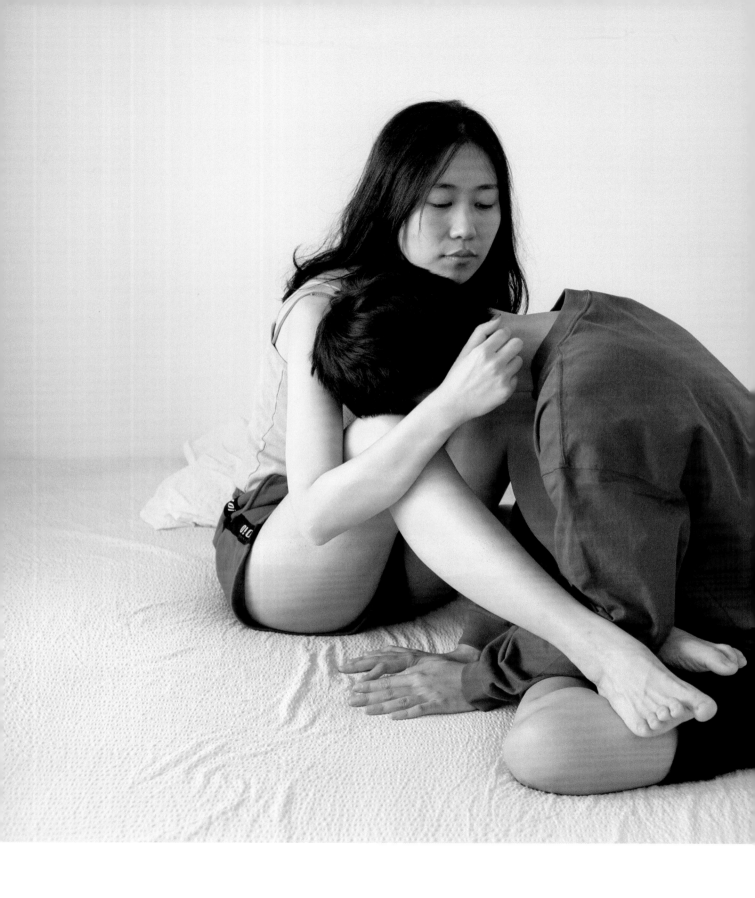

蔡哲敏
Cai Zhemin / Lai Xiaoli
赖晓莉

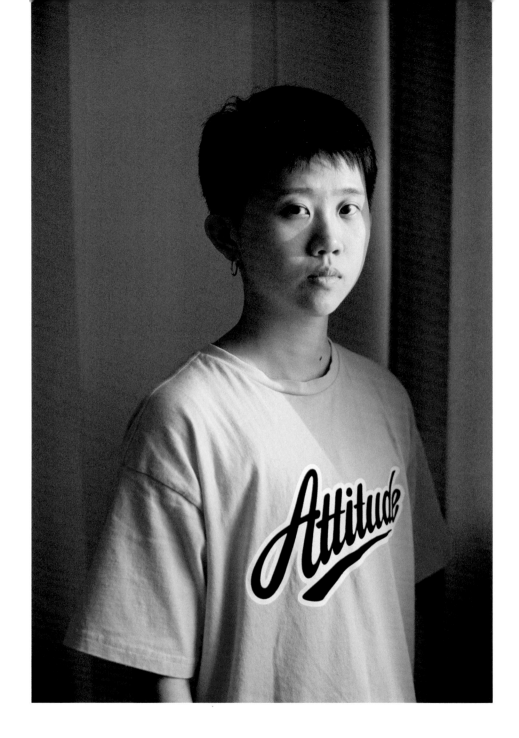

Lai Xiaoli: I grew up in Shenzhen, Guangdong Province. My greatest challenges have been the failure of my parents' business before I could comfortably support myself, and that I'm still not able to help my parents. How did I become who I am today? I've always tried to keep it easy and remain in control of my emotions. I feel that everything is fated. I'm afraid I won't be able to live the life I want, but I also believe that things will slowly get better.

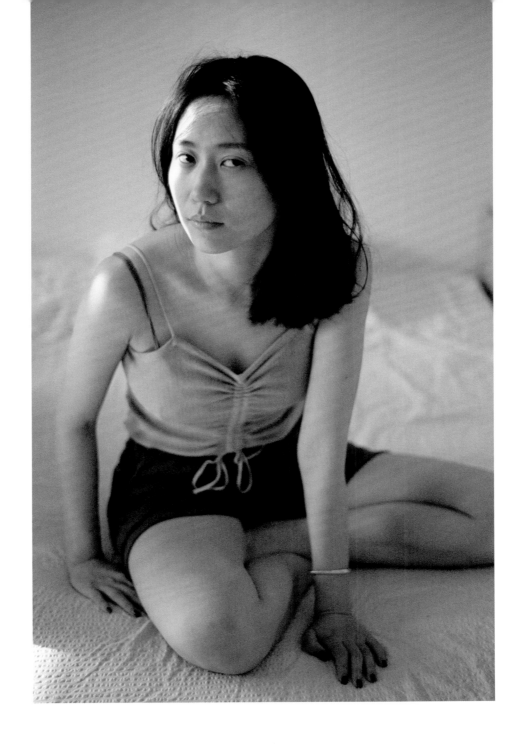

Cai Zhemin: I hope to live a good life, have a big house, travel the world. The difficulties I've run into so far are all challenges I've set for myself. Nothing is more important than bettering myself. I make progress one step at a time, enrich myself along the way, confront problems as they come, and never settle. I think that as long as I'm strong enough, I can overcome anything. »

Lai Xiaoli: I hope to make enough money in the future to meet my daily needs and help my family.

Cai Zhemin: Family is very important to me. I love my parents deeply, and I'm quite carefree in front of them. If I have any problems with them, I will tell them. We are very accepting of each other, and our relationship is very open and equal. ››

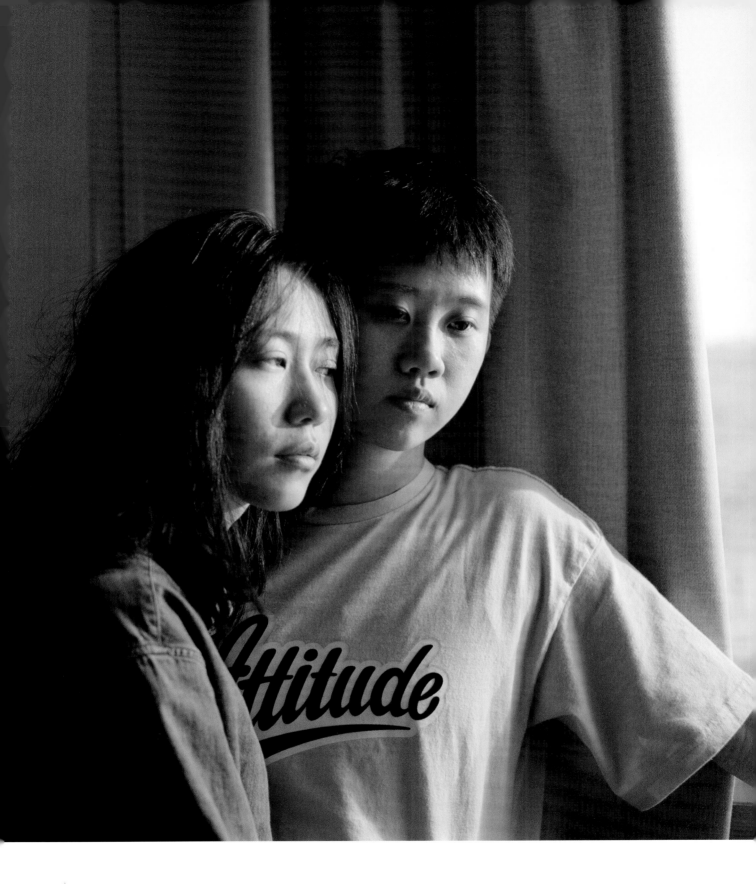

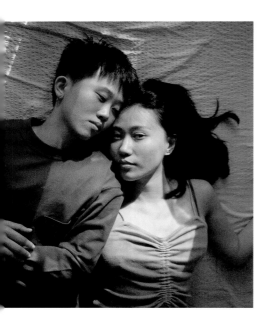

Lai Xiaoli: In my eyes, family members with blood ties trust each other completely. That is, whether rich or poor, good or bad, we are always a family. My younger brother and I, we've always been very close. He's very mature. My dad is an Aquarius: idealistic and unrealistic. I've always had fun conversations with him. We would watch movies and learn about the unsolved mysteries of the world together. My mom is stricter. Growing up, she scolded me more often. For a period, my younger brother and I didn't like our mom; of course, we were just kids. Now, I feel for Mom's toil—she shoulders more responsibilities than Dad does. But I'm a little uneasy in front of her; I feel like I owe her, but I can't help her. 田

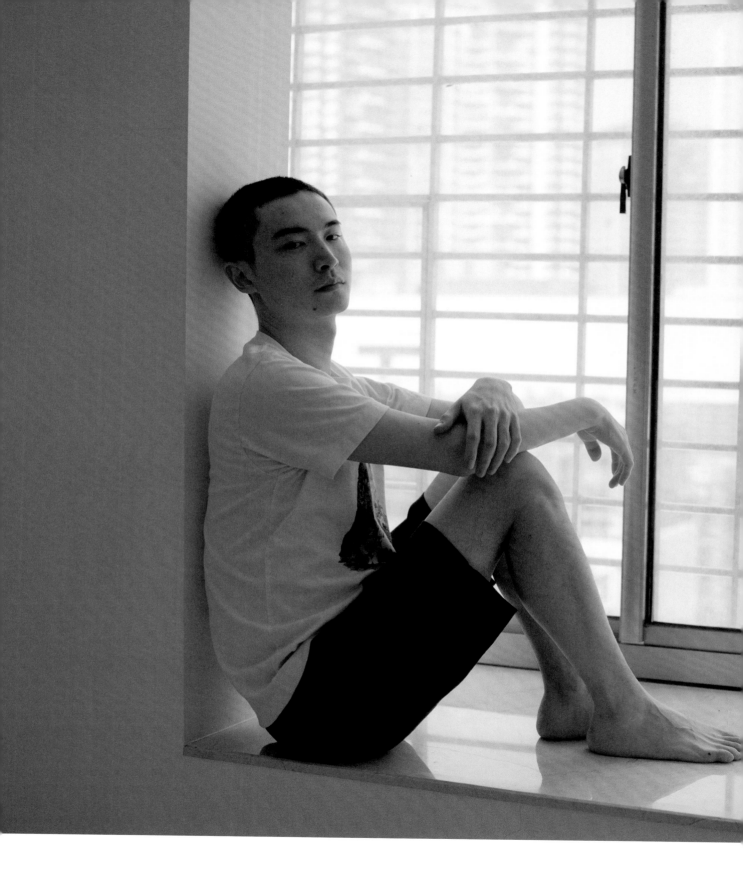

陈泽
Chen Ze

I'm a very ordinary person. I was born and raised in Xiamen. I'm twenty-six. I work two jobs, but money is still very tight. Every morning, I get out the door around six in the morning and work until seven or eight at night. After work, I hang out with my boyfriend and my friends until around eleven. Then I go home, take a shower, and go to sleep. My days repeat like this. I do my best to finish all the work coming my way and I feel there's nothing I can't accomplish. I try to learn, explore, and experience new things so that I can absorb and internalize them as my own. The challenge I now face is that I feel stuck; I'm unable to make a breakthrough but I don't want to settle for less. I feel ready to try anything, but at the same time not very willing to act on it.

My boyfriend and I met while I was working at a coffee shop. He was a customer. It took me half a year to court him. We've been together for a year and a half now. I have a so-so relationship with my parents. Growing up, we barely talked with each other. I think that family is a home one can always return to. I hope to become financially independent someday.

I'm at a loss when thinking about the future. I can't quite get used to the way society works and the way people interact with one another. I hope China and the Chinese people can confront certain issues. Don't act like problems don't exist just because you ignore them. It's useless and irresponsible to simply bottle them up. People are too selfish. Perhaps this is a problem specific to China. Nowadays, Chinese people feel exhausted just from taking care of themselves—they couldn't care less about others. 🔳

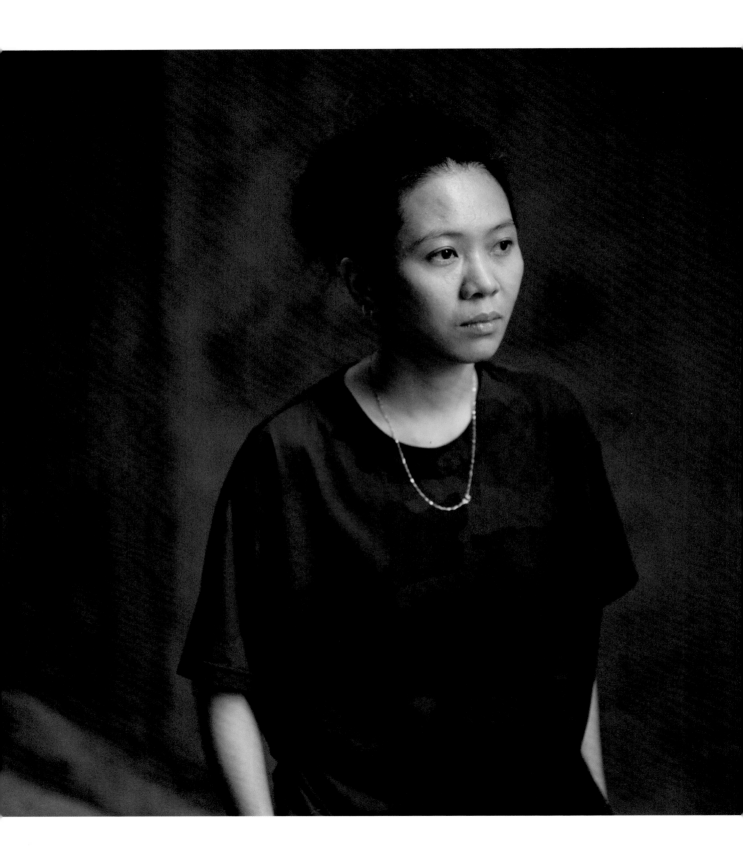

姚彩霞
Yao Caixia

I come from Shantou City in Guangdong Province, a city known for its gourmet food and gongfu tea. I left school at age sixteen. I once opened a dance studio, ran a clothing shop, worked as a dancer in a bar, and became a sponsored female skater; I eventually earned a national skateboarding coaching certificate and first-level referee certificate (although they seem useless). I've also worked as a telemarketer, a waitress, a street vendor, and I've filmed a few small ads. I also like to do woodworking. Now I'm running an Airbnb in Xiamen while doing marketing and operations for a skateboard brand. I feel I'm bearing the brunt of not having a good education. I've tried all sorts of things with a mixture of success and failure. I am who I am. I don't know how to define myself. I'm just an ordinary person who likes to be free. If you come across more labels for me, they were most likely given to me by others. I am content with myself and try to go with the flow. I believe I can overcome any obstacles over time. When I look back, these obstacles will no longer be obstacles, but just vignettes of my memory.

I know very well that I'm first and foremost a woman, and the people I'm attracted to happen to all be women. I don't like for others to consider me a man because I am a woman. I've dated all different types of lesbians and bisexuals. I tend not to differentiate my identities, perhaps because I'm more gender neutral. As long as I like, I'm willing to accept people of different identities. ››

I've had different understandings of love at different times. When I was younger, I thought love was all about passion—when it left me, my heart ached. Now, I believe love is having the patience to be with one another even through uneventful times, and to have the courage to separate without stirring up drama, because real life is larger than love. In the future, as I grow older and have more experience, I might have a new understanding of love again. But this should be normal because there is no standard answer to the question of love.

There is a saying in Chinese that "the greater the expectation, the graver the disappointment." I cannot guarantee what my future holds, so I try not to think too far ahead. Right now, I think I should focus on improving and enriching myself, exploring the outside world to broaden my mind. If I want to do something, I'll just do it. In the future, I won't give up my dreams in order to conform to reality. I'm wildly free—this is how I feel now and how I want to feel in the future!

I'm very grateful to my family. I feel very lucky to have grown up in a loving home. My optimism certainly comes from my family. Growing up, I saw my parents argue only once, and they made up on the same day. Although my mom is not well educated, she has her own principles when dealing with people and going about life. My mom died of illness many years ago, and my dad is seventy years old now. Every day, he goes out singing with friends. Occasionally, he travels. He is very optimistic. Every time I visit home, he holds my hand to go grocery shopping in the market. I also have two sisters and one brother. Although we all live in different cities, we are connected by these miraculous blood ties. I can't say family is everything to me because I have my own life, but family does provide a safe haven for me. So far, I've come out only to my sisters. My eldest sister says that everyone has their own lifestyle and pursuits, and that she respects my choices as long as I'm happy, but hopes I won't tell my father in case he can't accept it—he is much older than us, after all. Every time my dad urges me to get married, I feel irritated! 图

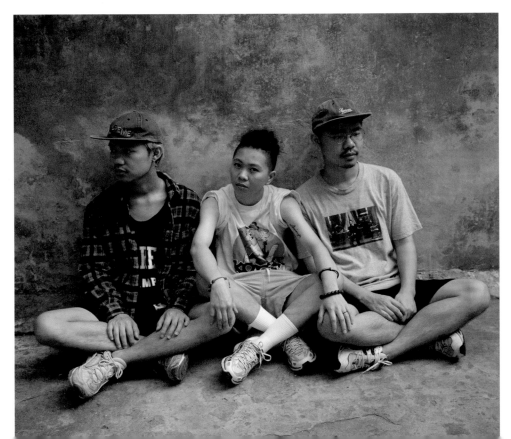

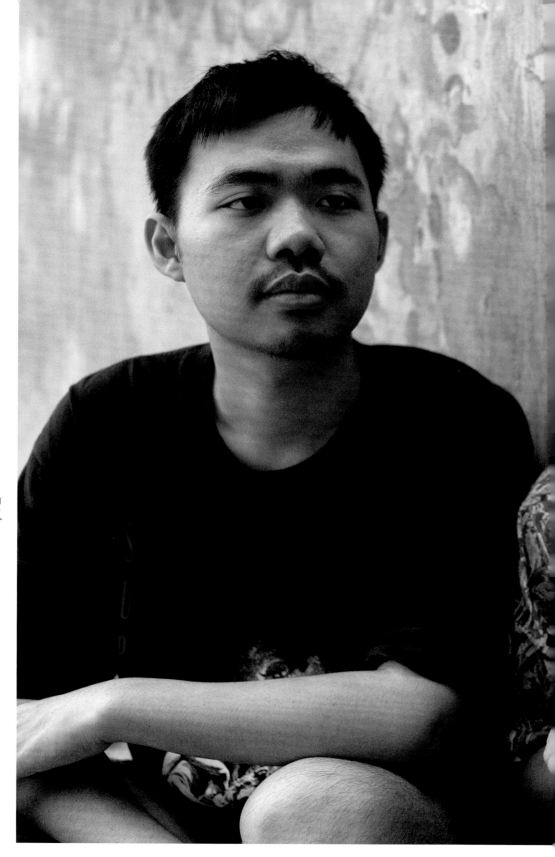

丁恺榕
Ding Kairong

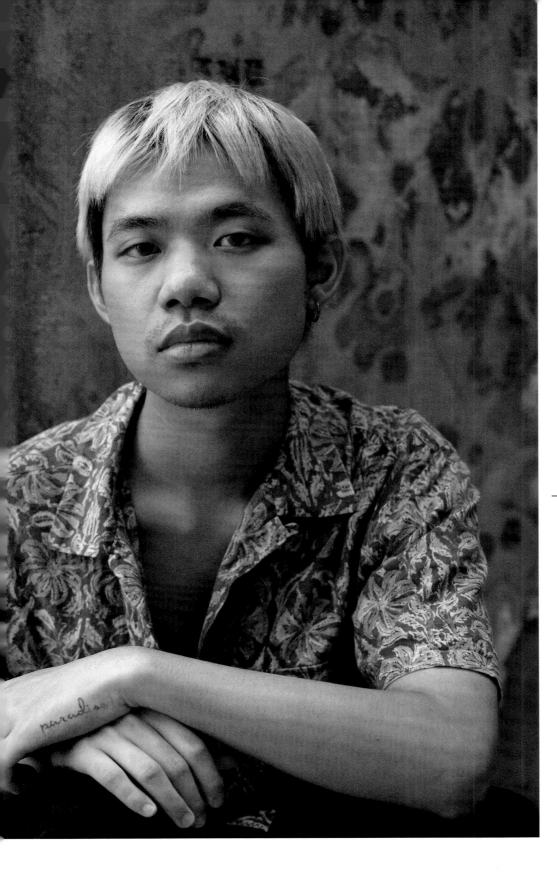

丁恺森
Ding Kaisen

Ding Kairong: I don't like to call my brother *gege*, "older brother." I've always liked to call him by his name, maybe because we're more like best gay friends. We talk about men, music, and films because we have the same tastes. He knows how to stay true to himself better than I do. My mom often says he is a bad influence on me. In our friends' eyes, we are like conjoined twins—always sticking together.

> **Ding Kaisen**: We often share our thoughts—happy or sad things—with each other. We've always encouraged and supported one another.

Ding Kairong: A major challenge I have might be that my life is too easy. It's impossible for me to escape my comfort zone because I'm afraid to make changes. In high school, I didn't want to leave Xiamen, so I chose a mediocre local university after I took my college entrance examination. I didn't want to leave my family, so I chose not to live on campus and was reluctant to make friends in college. In my sophomore year, I made the difficult decision to drop out of school. But I don't regret it because I hate going to school. I've never liked school. How did I become who I am today? Maybe through my job at Fat Fat Beer Horse, where I met all kinds of people who've influenced me a lot. I started to work part time at the Beer Horse after I graduated from high school. In the beginning, my elder brother and I didn't like to talk to others, but minded our own work. Our manager Tianzi is a very cool girl. She's influenced us in many different ways. We learned to be ourselves without worrying too much about what other people may think. She introduced us to a different social circle.

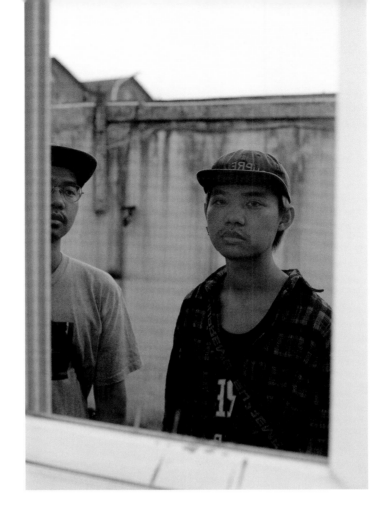

Ding Kaisen: When I was a child, I lacked self-confidence and was very depressed, which might have come from my family environment. I felt nobody around me could understand me—they thought I was weird. But when I grew up and expanded my social network, I began to meet people who understood me and always encouraged me to be myself. I'm very grateful for my current workplace, which allows me to meet a group of friends who deeply care about me and who've shaped who I am today. I was very unhappy about my body because I was very fat. But this year, I've spent three months losing weight, and I'm very pleased with the results. This has greatly boosted my confidence.

Ding Kairong: To me, family feels like a cozy place. But my parents do not know who I really am. My mom is very kind to me. She never scolded me for dropping out of school. She respects the different choices I make. I'm not sure if she knows I'm gay. My dad—I don't even call him "Dad"—used to beat me, my elder brother, and my mom frequently. Every time he drank, he turned violent. He's a lot better now. He doesn't dare hit us again.

Ding Kaisen: For me, family is a source of support that I can always rely on. Although I endured a lot of violence from my dad when I was a child, he has gradually changed and no longer resorts to violence. I've slowly begun to accept him. My mom and I are very close. When I wanted to buy something as a child, she always tried to satisfy my needs. But there are also many things about me that my mom can't understand. ››

Ding Kairong: I hope I won't be shy anymore when interacting with others. I hope to become more confident. I hope to settle down in a foreign country and find someone I truly love. Most important, I hope to stop falling in love with straight men.

Ding Kaisen: I'm afraid of dying alone at an old age. I'm afraid to fall in love with a straight man. I'm afraid that no one in this world can understand and accept me. In the future, I hope to meet someone I truly love, travel the world with him, marry him, build a family with him, raise several kids, dogs and cats, and spend the rest of our lives together peacefully in a suburb. 🏮

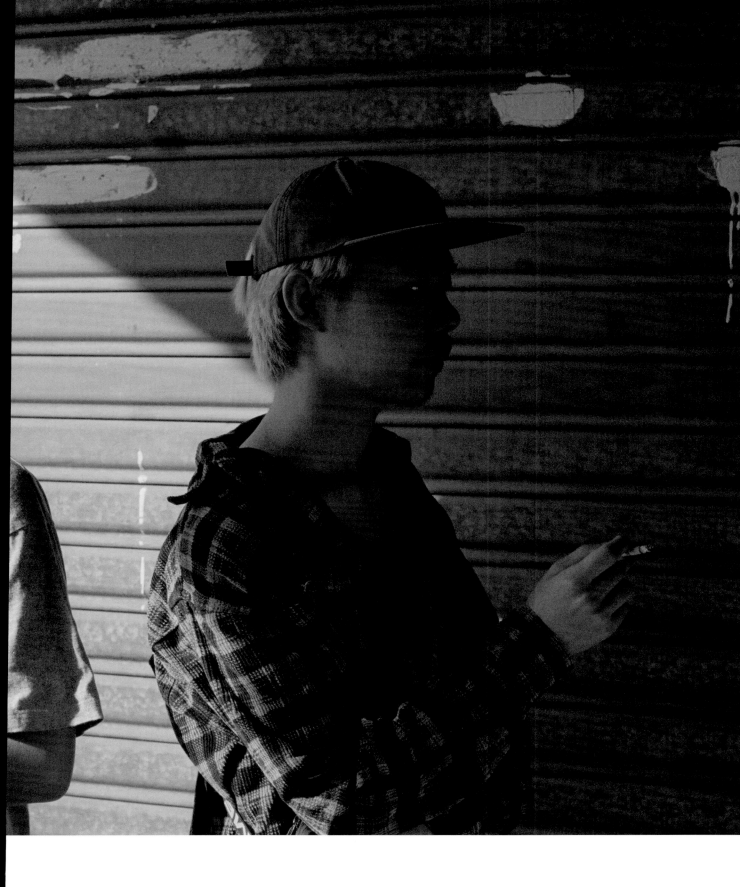

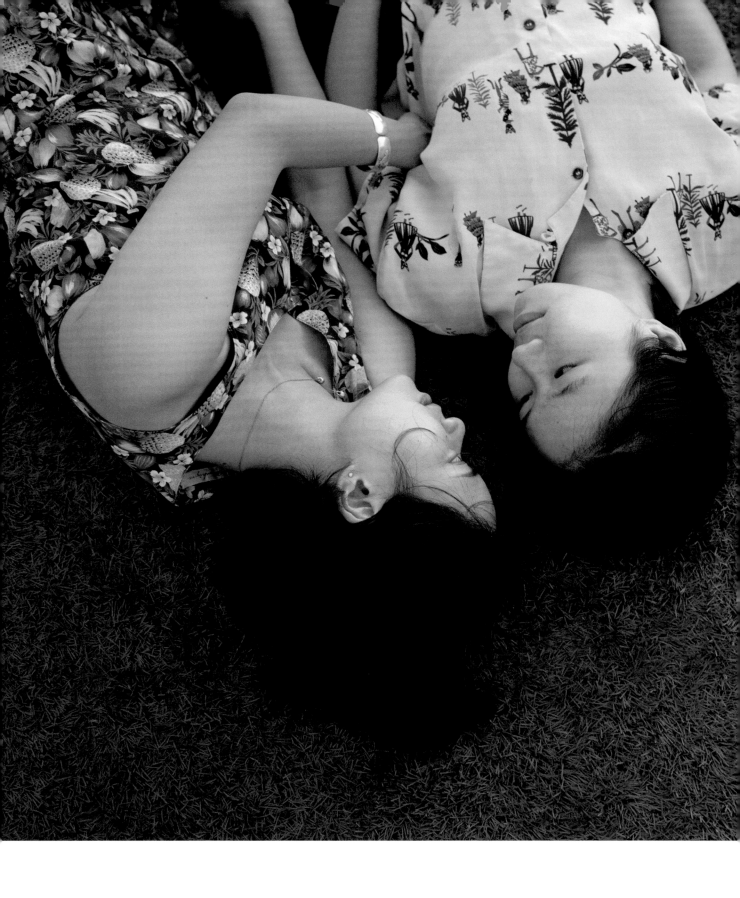

陈菲菲
Chen Feifei / Lu Ling
卢凌

Chen Feifei: We've known each other for four years and have been together for over a year. We were classmates in the same department of our college.

Lu Ling: During the second semester, after we chose our field of study, we began to do homework and field research together. Before we graduated, my advisor told us we had the opportunity to go on a field trip in Yunnan.

Chen Feifei: Often, in the early mornings, we would leave the wooden stilt house we were staying in and go from house to house looking for tea farmers who could speak Mandarin. Sometimes, we would climb through the tea plantations to observe the farmers picking tea leaves. There are many stockaded villages in that area, but even the closest ones are still two or three kilometers apart. To get from one village to another, we would take the narrow stone paths through thick groves of trees. We chatted. We grew close.

Lu Ling: We took care of one another, and slowly developed feelings for each other.

Chen Feifei: I was born in a village on the coast of Fujian, where sexism runs deep. Most young people get married and have children early. Probably starting around middle school, I felt compelled to reject the kind of life the villagers had envisioned for me: drop out of middle school or high school, meet someone my age through a family arrangement, and set a marriage date—or even get married—within a month. Education seemed like the only path to rescue myself from this "tradition." Luckily, my parents are more open-minded. They have always supported my education. But I could only avoid the neighbors' gossip if I aced the national entrance examination and went to college. My desire

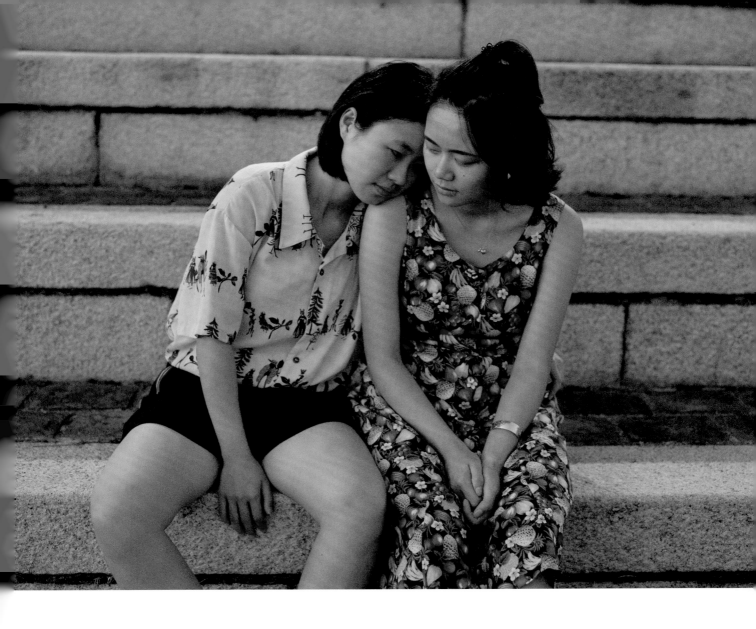

to leave the small circle of my hometown was one of my primary motivations to study hard in high school. One time, my mom joked that if I didn't want to continue school, I could always get married. She was just trying to comfort me after a disappointing final exam result, but I lost it and burst into tears. For the adults, going to college was an option, while marrying a man—even better, a man from the same hometown—was an obligation. I am afraid of my parents' homophobia and their expectation for me to get married, have children, and build a traditional family and career. For me, going to college was the only way to break the shackles of marriage. »

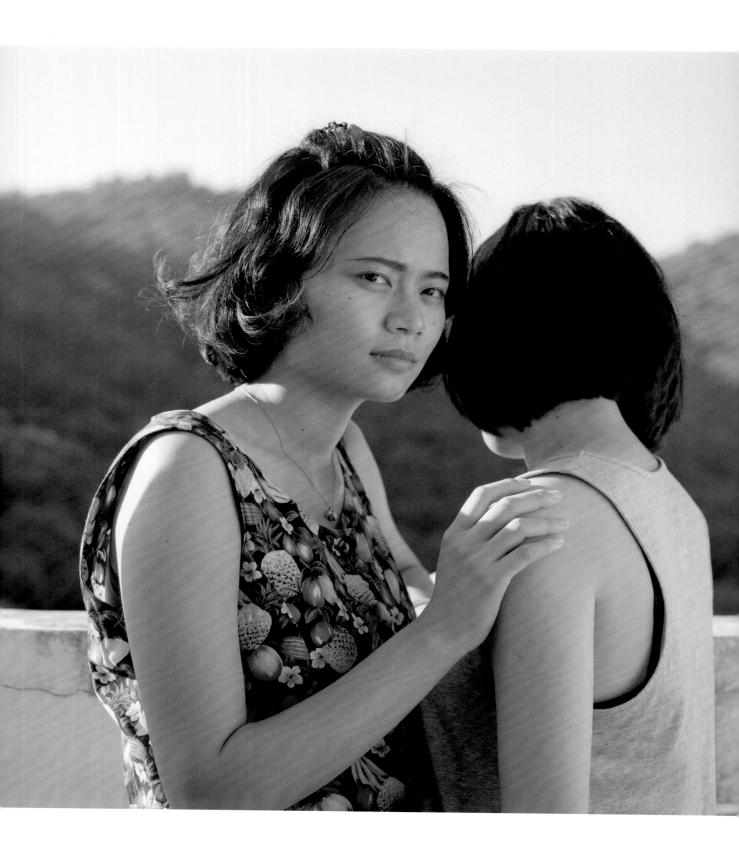

Lu Ling: I come from a small coastal town. I'm now studying anthropology in college. To be honest, I'd never thought about my sexual orientation before college. I'd never questioned the fact that I was straight, although I'd never excluded any gay friends. My college program conducts a lot of research on social issues, and it has cultivated a highly inclusive culture. In fact, I'm deeply grateful to my school, my program, and the fan fiction I grew up devouring—taken together, they've presented love's possibilities and allowed me to accept myself when I met someone I liked. My roommates and friends in college also helped me to see my changes from their perspectives, and I've felt accepted and loved by them. When it comes to identifying with my sexual orientation, I've almost never struggled or met any resistance. I identify as a woman, but my sexual orientation is fluid. I try not to define myself. Labeling myself feels like reinforcing my present status and suppressing the possibility of change.

Chen Feifei: I identify as female. My sexual orientation is fluid. I never had a problem with queerness. I even read queer slash fiction. In college, I gravitated toward subjects like gender fluidity and queer identity in my gender anthropology class. It was only natural that I later became attracted to women. If there is any difficulty now, it's the pressure to get married I'll face from my parents after grad school. For now, college is my safe haven.

Lu Ling: Whether I continue studying or start working, I hope to become financially independent and spiritually free, to have lasting hobbies, and to always stay healthy. Nobody is born prejudiced, but there are prejudiced educators everywhere. My hope for society is that people will teach their children to listen to other voices. 🔳

洪耀达
Hong Yaoda

Love is an urge to connect with others. Prior to this, all the emotions I experienced—distress, sadness, anger, happiness—were there to help me decide whether I wanted to continue making a connection with someone, something, or some event.

In my understanding, I am a man who likes men. But in fact, I'm quite indifferent to my gender identity. It just so happens that I'm a man, so I see myself as a man. Or perhaps camouflaging myself by saying "I am a man" is just a way of making it easier for others to accept me. When I was a child, I was known as a sissy in school. My parents repeatedly lectured me not to "behave like a girl." Back then, I also couldn't identify with my girly behavior as a boy, so I tried again and again to remake myself. Now, I find that this "camouflage" doesn't bother me anymore, so I simply admit that this is the real me.

As for sexual preference, I think I'm more attracted to men. When I was a teenager and began to peek at porn, at first I would substitute myself into the male roles in these films, fantasizing about their female partners as my sexual objects. But I gradually began to be drawn to the male characters in those films, and began to imagine myself as their female counterparts.

I think China's attitude toward homosexuality will certainly become more open. The Chinese government's current stance on homosexuality is actually very neutral. You can see evidence of this in China's laws—they've deleted all the regulations targeting the gay community. Today, you can hardly find anyone being dragged into a lawsuit in China because he's gay or has done something "only a gay would do." Instead, it is Chinese society that remains intolerant of homosexuality. It's unclear when Chinese society began shunning gay people. While current laws remain neutral, old prejudices have been preserved through persisting social biases. Fortunately, progressive values of a few powerful nations will inevitably influence Chinese society. In reality, China's public opinion is evolving from "Every homo should be condemned" to "I don't care about gays; I just find them strange." And in big cities, young people have long accepted their gay friends. ››

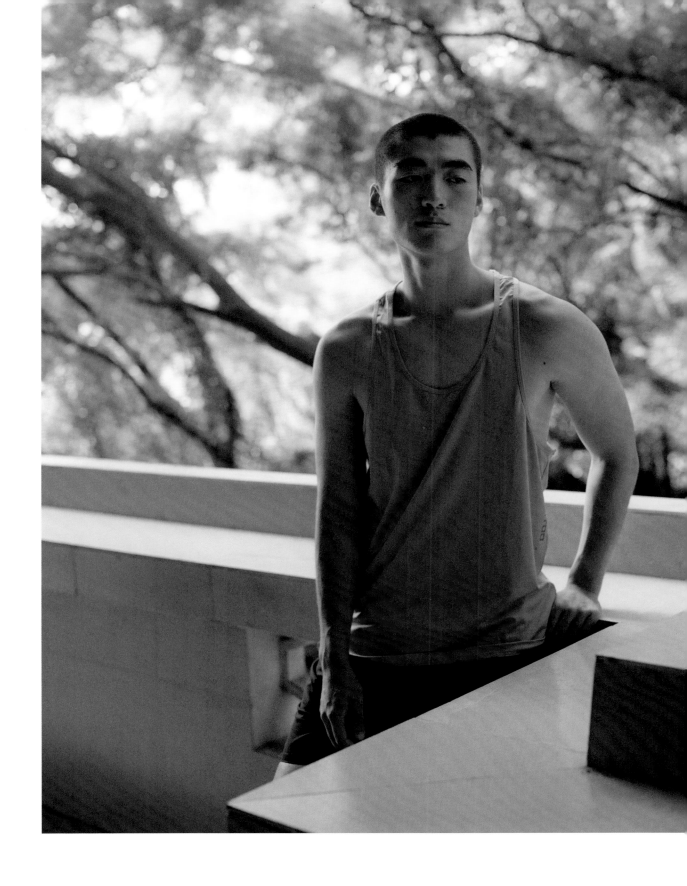

We have every reason to believe that Chinese society will become more and more open toward the LGBTQ community. But simply being tolerant is not enough. I hope the public can shift its focus away from LGBTQ labels. To this day, we are still constrained by all kinds of labels.

I can now disclose my sexual orientation to anyone other than my parents—that's another issue. Staying open and honest about my sexual orientation brings a series of problems that no longer bug me but can distress my friends and my family members. If society can stop paying so much attention to our labels, I'm sure it will relieve a lot of the stress felt by those around me and those whom I love.

I'm a student at Xiamen University. I come from Shishi, Quanzhou, Fujian Province, a region with an overpowering clan culture, where locals are typically conservative and xenophobic. I was very introverted until I went to college. I think the main reason was my compulsive self-criticism, always blaming myself for the things happening around me—it seems to be a common problem that children suffer from. In college, I learned that, although self-reflection is a virtue, there are too many things in the world that can't be solved by self-reflection alone. But I'd always assumed that I must take responsibility for everything.

I've been taught since I was little that it's evil to shirk responsibilities. Even now, I still don't think this view is wrong. I was torn by the sense that it is just to shoulder responsibilities and by the belief that it is cowardly to fail to shoulder them. But I never knew that my parents could—and should—have helped me process these feelings, because my family was often the root cause of my mood swings. Often, when I confided in them, they couldn't respond to my feelings properly. Worse yet, my confessions inevitably disturbed them, and they would pass their emotions on to me. The result was that, although they are now able to manage their emotions, I no longer believe they can understand and take care of my feelings. I understand that they're just as hurt and powerless as I am. After all, their pain probably came from their parents. I can understand it, but I can't accept it. This might be a scar for them, too.

Other than distrusting my family, I also shut myself off from others. I couldn't share my feelings with my teachers or other adults because I believed that all the adults were there to help my parents monitor me, which proved to be true. I also couldn't confide in my classmates because they couldn't offer any solutions for me. Or rather, I thought they were just like me, afflicted by the same problems. ››

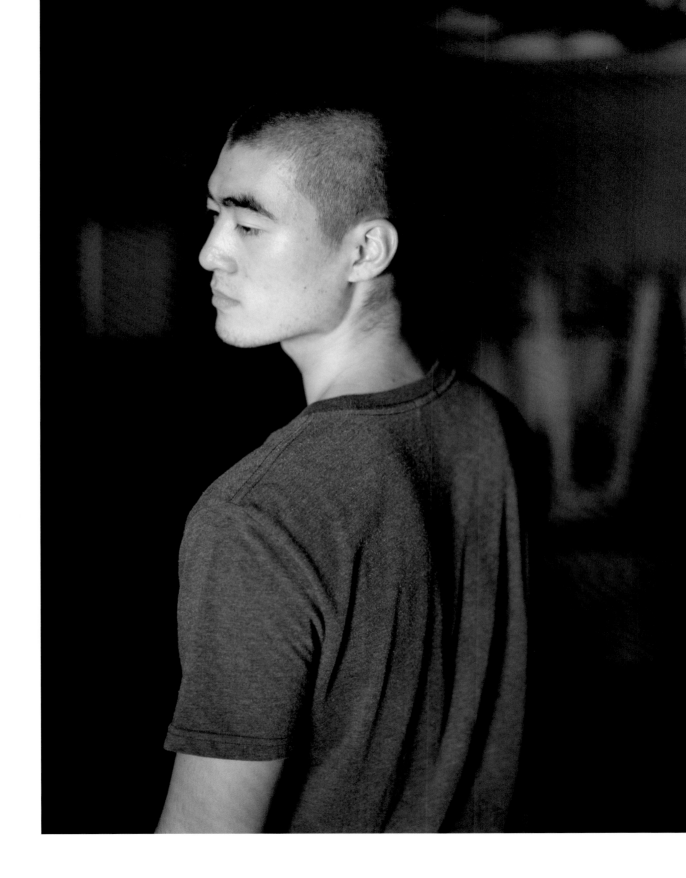

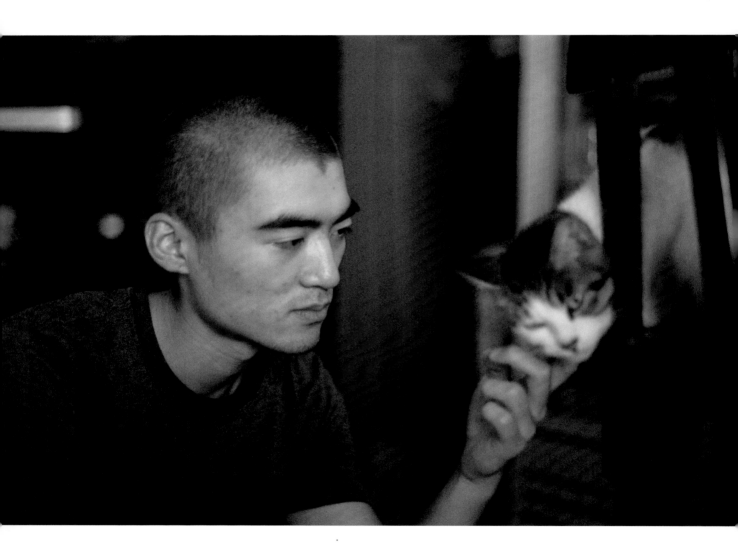

I began to fall behind in school; this was the topic my parents talked about with me the most. What's more, my mother took extreme measures to resolve this problem. When I was in third grade, for instance, she discovered the comic books I'd collected over a long period of time. She tore them all up in front of me, trying to force me to return my attention to my studies. I suffered from my parents' constant supervision and my stagnating grades. Subconsciously, I began to clam up, trying not to feel anything.

A turning point came when I was eighteen. I thought I'd caught AIDS and that I was going to die. I left Shishi for Guangzhou to prepare for the college entrance examination. Far away from home and overcome by my sexual desires, I met guys through gay hookup apps. But one time, my partner didn't use protection. I was inexperienced and was very sensitive to the topic of AIDS as a member of the LGBTQ community, and there was no professional support. I bought an AIDS testing strip and, because I applied it incorrectly, the test results came out positive (indicating that I had AIDS). For a long time, I contemplated life and death. During the day, I went to my classes in a wretched spirit. At night, I cried in my bed. A month later, I decided not to give up hope, so I took another test. To be safe, I bought multiple test kits that used different methods, and ultimately proved that the first test had been a false alarm.

After that, I learned to take everything calmly, and began to let go of certain things—the things that had brought me pain because I cared too much about them.

The next turning point was a little bizarre. I got sick right before the Lunar New Year when I was twenty. I had a fever for a week; after I recovered, I gained a new ability to be more critical toward others. I learned to stop tolerating others' faults and suppressing my natural tendency to blame others. I began to realize that my needs were not mere desires, and accepted that I deserved to have actual desires as well.

Right now, I feel young and fearless, and I sleep well every night. The only thing that bothers me is that I'll graduate soon and need to plan for the future. 🏮

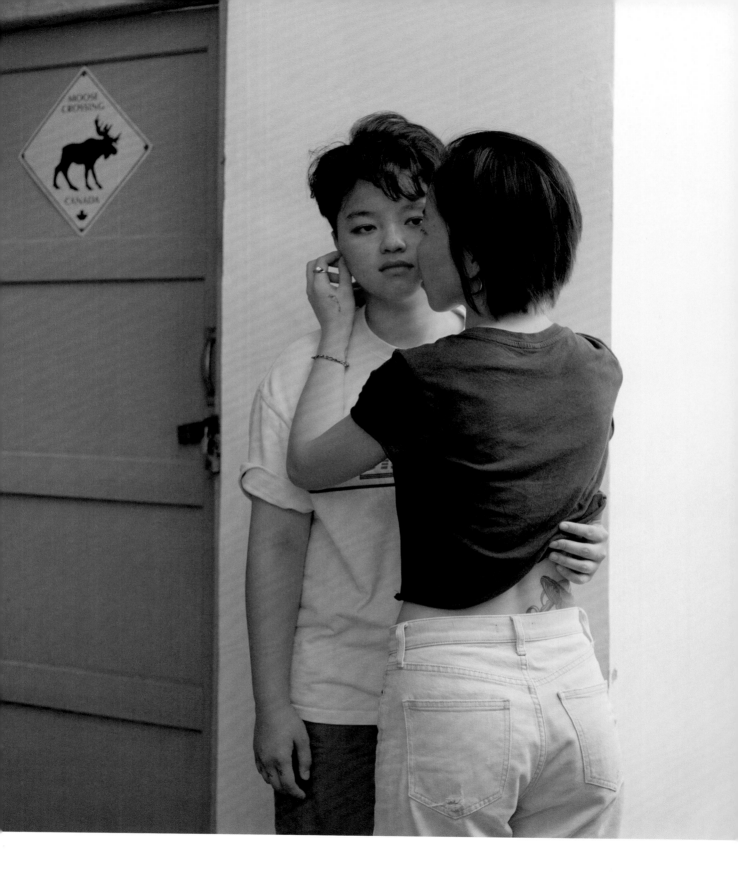

柯倩
Ke Qian / Cai Peijing
蔡培晶

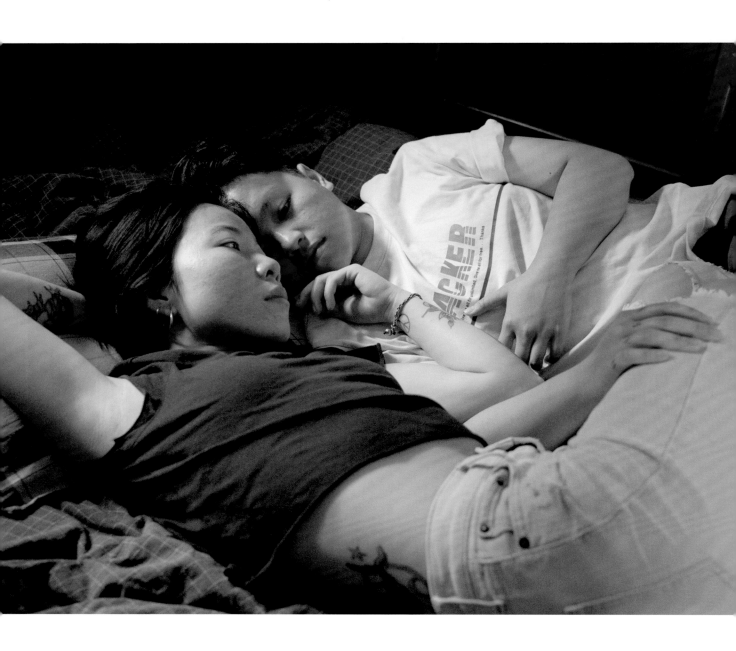

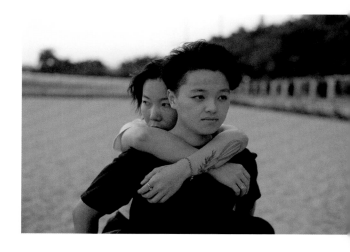

Cai Peijing: I'm from Xiamen, Fujian. Psychologically, I am a man. Physiologically, I am a woman. I was always running into problems when I was growing up, and felt I couldn't overcome them, so much so that I struggled with self-denial. I also tended to exaggerate and overreact to small things in both good and bad situations. But these experiences have shaped who I am today.

 Ke Qian: We've been together for almost five months.

Cai Peijing: We were friends for more than a year before we started dating. I met her through a mutual friend when I came back from Shanghai.

 Ke Qian: The friend brought her to try some of the desserts I had in my studio. I'm originally from Qingliu County, Sanming City. I now live in Xiamen as a freelancer. Due to the nature of my work, my long-established lifestyle of living alone, and the many friendships that fulfill my life, I see romantic relationships as being a matter of quality over quantity. Love is about mutual respect, companionship, and growth. In the past, I thought I was only attracted to boys. But now, I'm quite sure that I'm bisexual. Living alone over the years has caused me to grow distant from my family. I feel most comfortable when I only have to live with them one week per year. ››

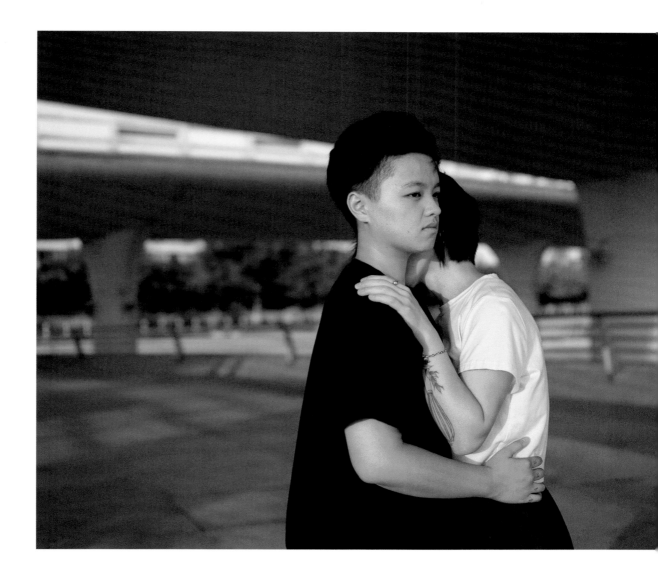

Cai Peijing: My original family wasn't happy, which is the main reason I want to have my own family. I hope to build a happy family of my own—provided I have enough confidence. At the moment, family isn't everything to me, but even if family took up only a small part of my life, it cannot be ignored. My relationship with my family is also evolving. Over time, my attitude has changed from avoidance to trying to find a middle ground so that we can maintain a relationship and reach a mutual understanding—especially with my parents. Whether for family members, romantic partners, or friends, love is an integral part of one's growth and self-understanding. It is a journey of mutual reciprocation. It is a simple but complex feeling that demands responsibility, tolerance, and patience. 🈴

蔡明威
Tsai Mingway

I come from Taizhou, Jiangsu, and now live in Xiamen. I am a very ordinary gay guy. I don't have the confidence to find someone to love me, and I'm way too picky to find love. Sometimes I will be very annoying because I feel nobody listens to me and respects my feelings. Love means respecting and accepting a person as they truly are.

I became who I am today through my own efforts but also with the help of many people. I have not yet achieved financial freedom, and I look forward to having a house all to myself, a steady job, and spending time with the people I love.

Family means memories of the past to me. I have a good relationship with my grandma. I have a real soft spot for her. I have a basic relationship with my parents—I have not lived with them since childhood. I also have a good relationship with my aunt. She has shown me extraordinary care and love since my childhood. 🈳

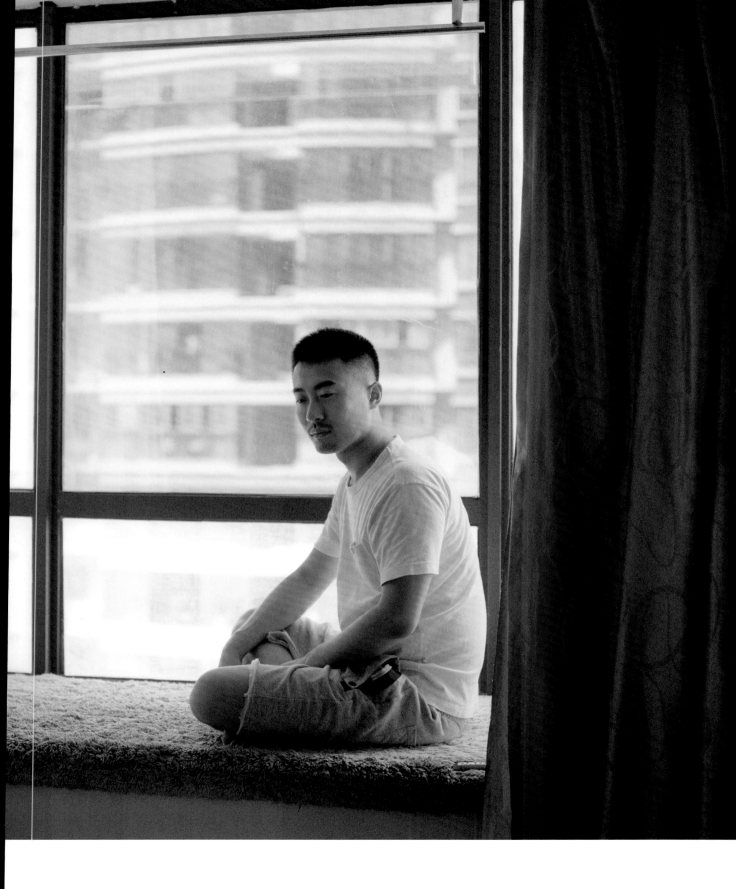

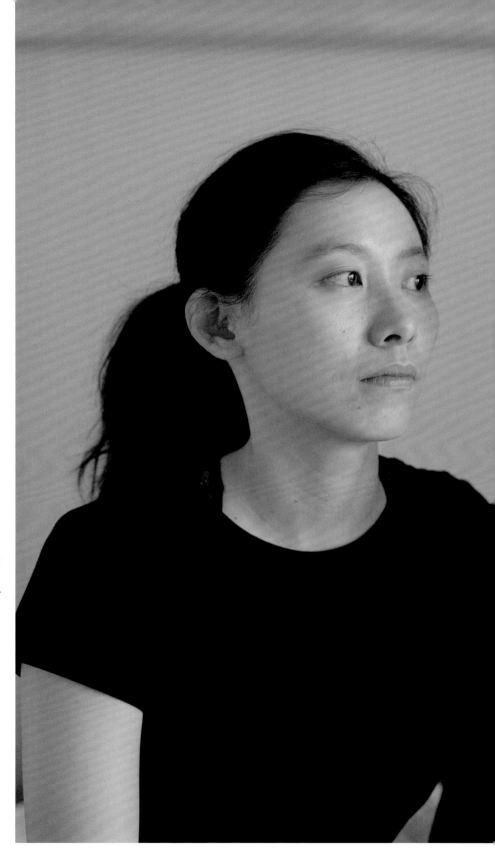

李华丽娅
Li Hualiya

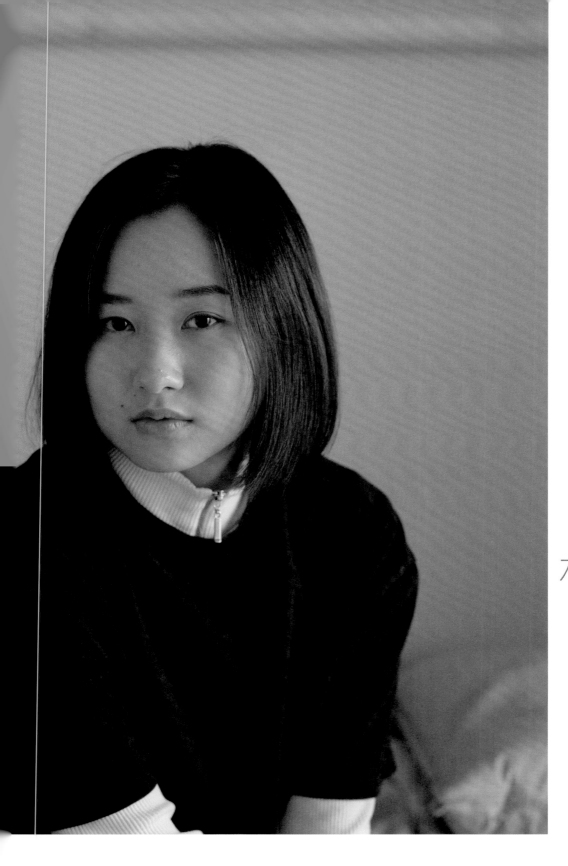

林茜芸

Lin Xiyun

Lin Xiyun: I was born and raised in China. I went to a boarding school when I was fifteen, so I spent only some of my time with my family growing up. I guess this experience made me a more independent person. I came to the Netherlands two years ago as an international student. After finishing my master's program in finance, I found a job here and then I stayed.

> **Li Hualiya**: I was born and raised in China. At the age of sixteen, I moved to Amsterdam, continued my studies, and started my life here. Sometimes I wonder where I belong, here or there. Recently I've been thinking about what home is. The definition of home has been changing constantly for me. My sexual orientation is less relevant to me in identifying who I am because my sexual orientation does not differentiate me from other persons much, from my perspective. I identify more with being Chinese.

Lin Xiyun: I met Liya one and a half years ago. We found each other on a lesbian dating app and then we started seeing each other.

> **Li Hualiya**: Xiyun posted a picture of her handwriting and I liked it, so I started to chat with her and asked her out in a park. I've spent most of my time with Xiyun these past two years. I appreciate and enjoy it a lot. ››

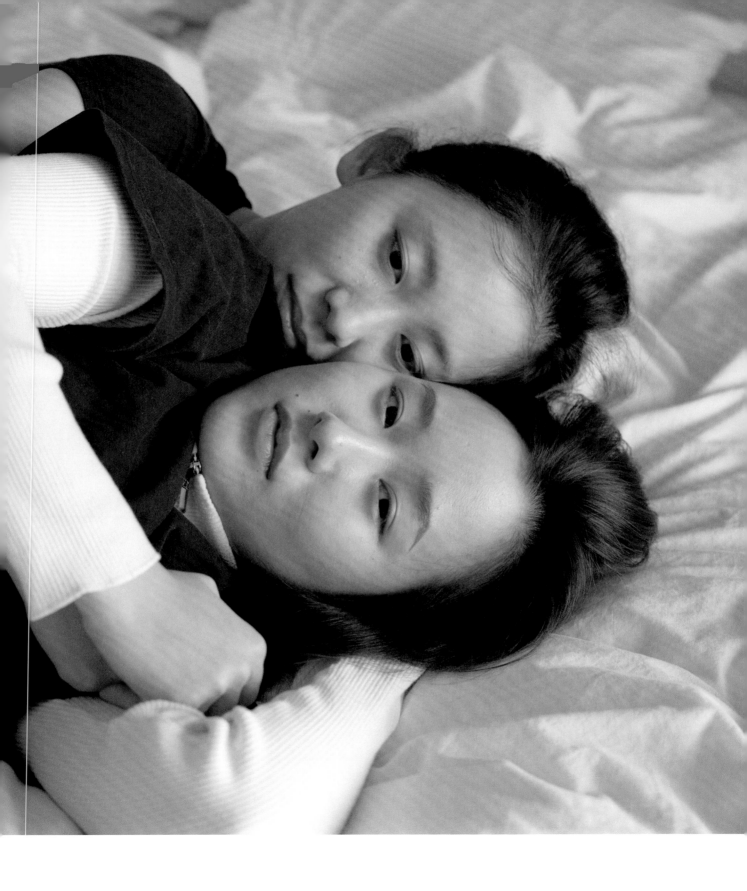

Lin Xiyun: Family means a lot to me. Family is a place where I can recognize myself from when I was a child. Family is also a place that I am a little bit scared of. I am scared if my mother is upset about me; I am scared if my family members don't feel I am outstanding anymore. Family is also a place where I can ask for support under any circumstances. I'm not sure what will happen if I come out to them. I think my relationship with my family can be considered as good. It used to be very close when I was in high school because I always shared all my thoughts with my family, and they always helped me out. But we started talking less after I came to the Netherlands. One reason could be the distance and the time difference. Another, I guess, is because I have my new life, my life with my girlfriend. It's impossible to share this happiness with them. Generally speaking, I would say the relationship is good but with some "distance."

Li Hualiya: My relationship with my family has always been quite distanced because I grew up with my grandparents. My family and I love each other. But we are separated by space, time, and all the complexities the world has to offer. What family means to me is, it is a race with time; I want to cherish them but sometimes it can be hard. 🏮

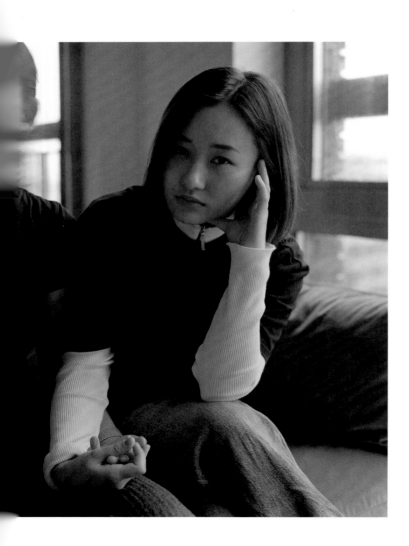

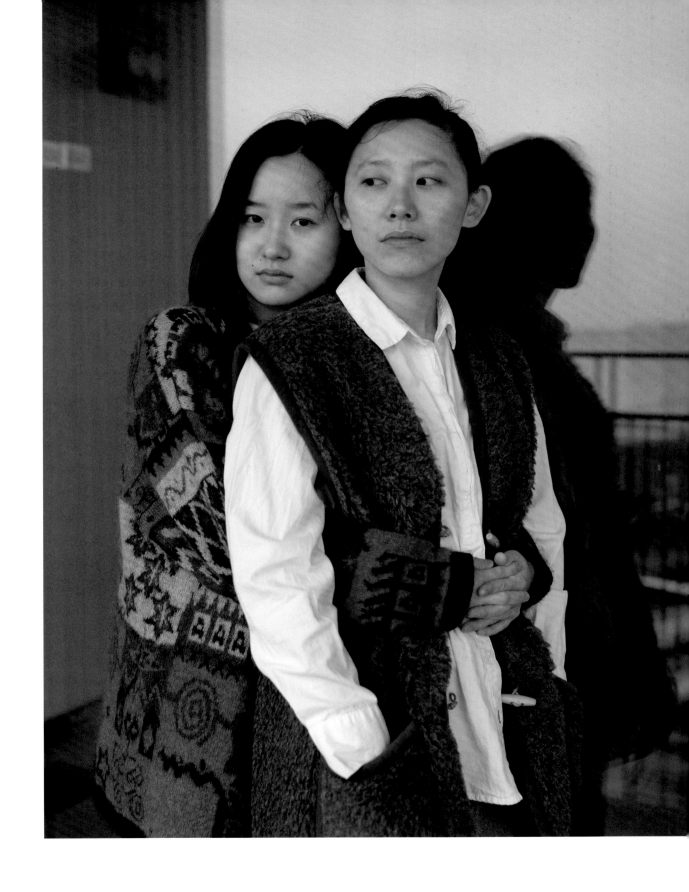

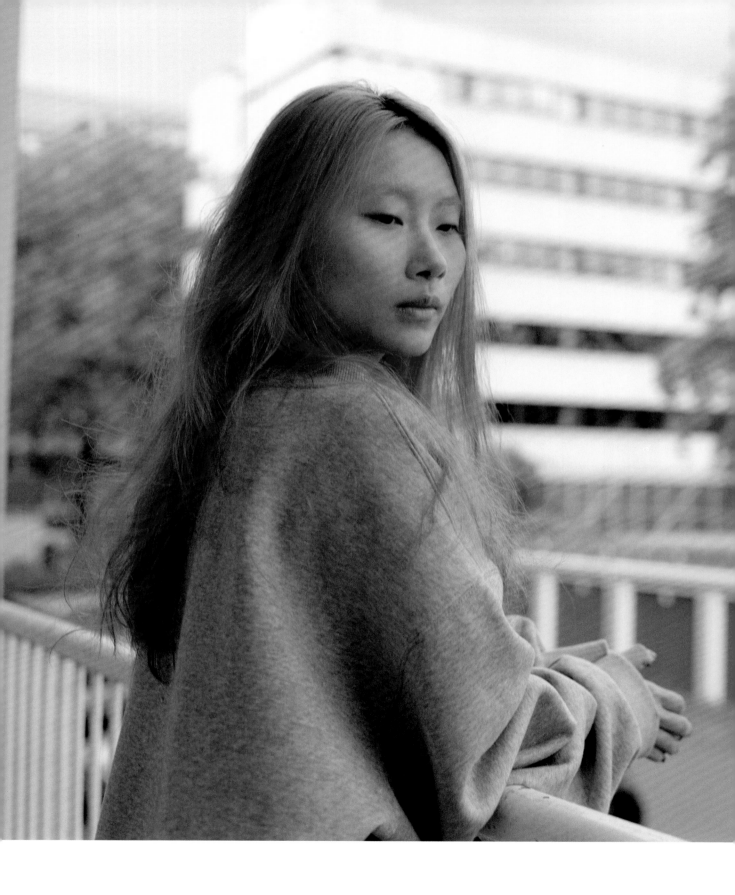

张陆

Zhang Lu

Love means courage and responsibility for me. Before my relationship with my ex-girlfriend, I thought love was fragile, that it sucked and sucks. Obviously I hadn't been in a healthy relationship. But she taught me and affected me. Although she had experienced toxic relationships, she was still brave enough to express love and led me to have a great relationship with her. I'm not a problem-solving person in the past, and I always panicked when I needed to take responsibility, but she would always be patient and help me to solve problems. She could get really pissed off, but she thought I could change. Then I started realizing I can't just take her love, I should give back; that's what I learned—the most important things—from her. ››

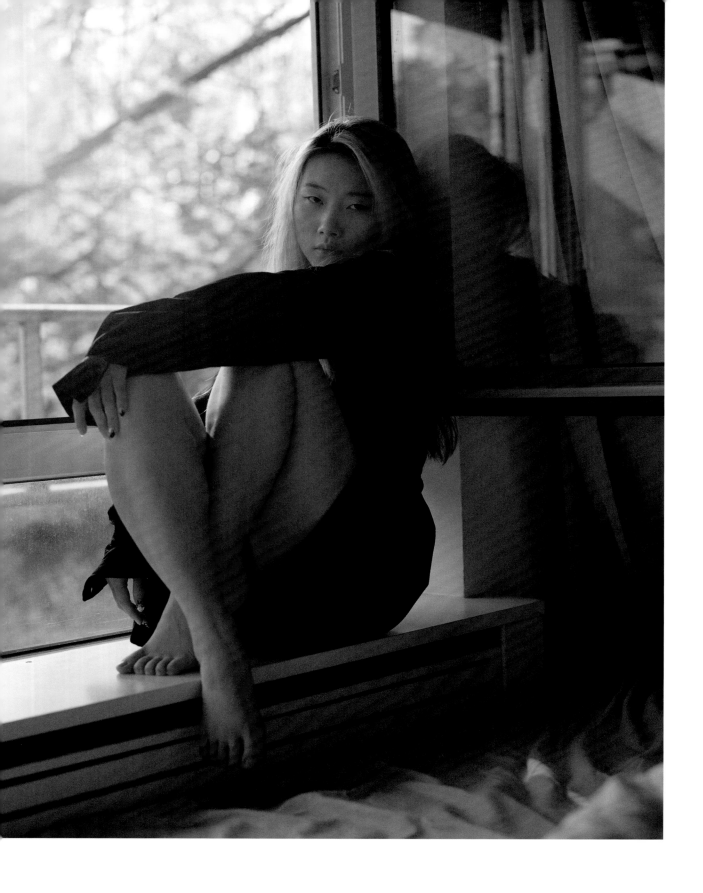

I identify as lesbian. Naturally speaking, I thought I'm 95 percent lesbian and 5 percent bisexual because I dated a boy. To be honest, there were many female characteristics in him, like showing off his makeup or making cute clothes for my hamster. When I was with him, I did not feel that I was in the male gaze or that I was oppressed by the patriarchy, which, based on my past experience dating men before I realized I was lesbian, is quite unusual.

I hope I can do more supporting LGBTQ+ groups in the future, and I wish China would legalize marriage for LGBTQ+ people. In my perspective, it is a long way to go. I don't think I will face sexual bias or discrimination in my future career because I've decided to work in Shanghai, which is my hometown and is a diverse and inclusive place. But I have concerns because the legal system cannot guarantee rights for my partner and me in the future if I stay in China.

Family means roots and connection for me. My family is kind of different from others because I have a little sister and my father passed when I was in senior school. I think my mom played the crucial role in educating me. She always told me she is beside me and supports all my decisions. I think family means connection because I believe family helps you to know the world and the thinking of the world. 🔡

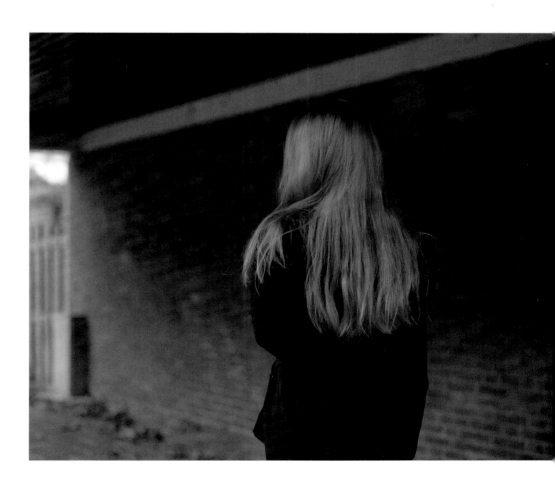

杨朝辉
Yang Zhaohui / Chan Davey
詹大为

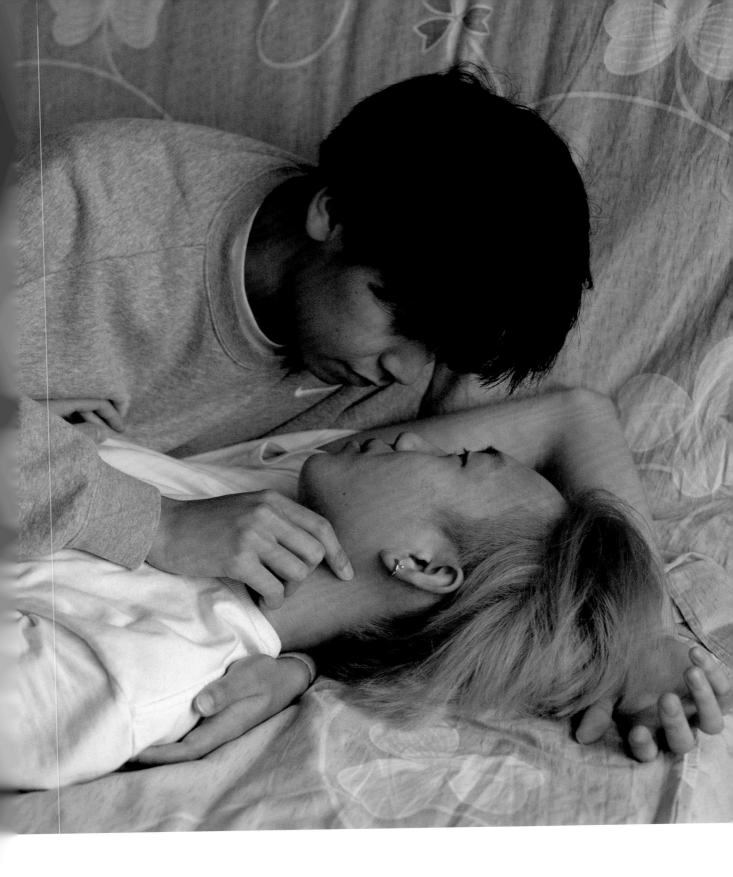

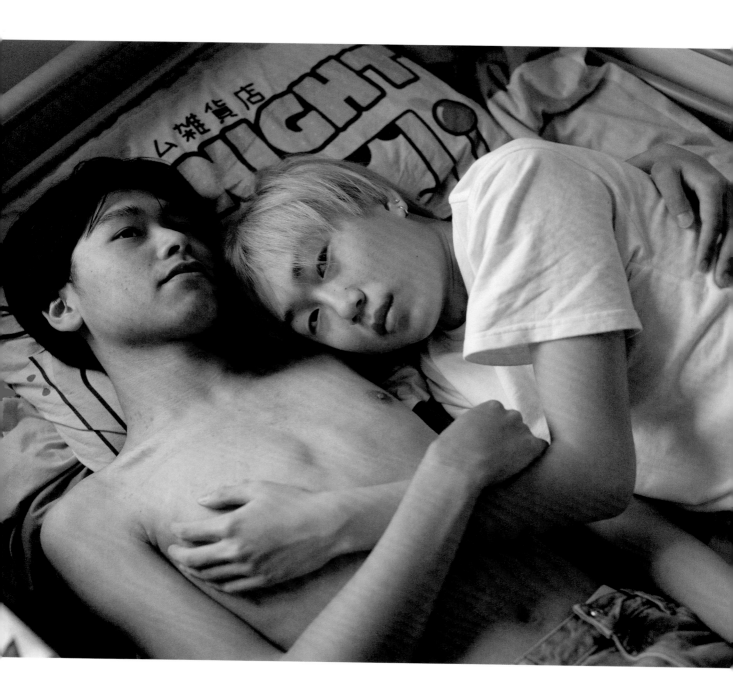

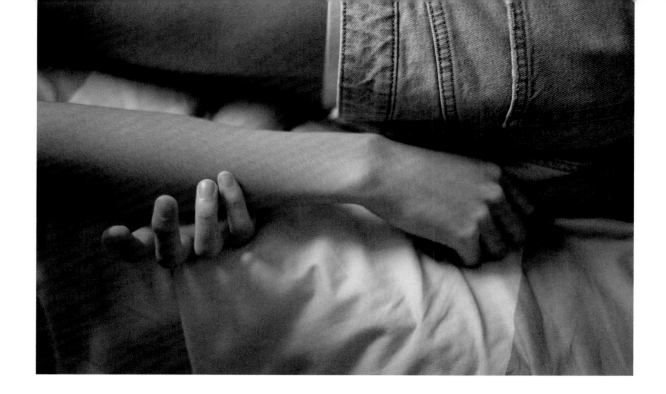

Chan Davey: We met in June 2021, so it has been only a couple of months. We saw each other for the first time during quarantine through the Discord server of the Chinese Student Association. Within our Discord server there is a channel where you can study together with other people in silence. And then, somewhere in May, one of my close friends met my boyfriend in real life during a get-together with some people from the student association. So one day we decided to hang out the three of us together, and then slowly we started hanging out just the two of us. That's kind of how it all started.

Yang Zhaohui: We gradually found that we have the same interests and started to go to museums together and that was the time we started dating. I'm originally from China and I'm now pursuing my bachelor's degree in the Netherlands. To become who I am now, I'm so thankful to my friends in middle school. I was so lonely and I was bullied in primary school because I didn't behave like a "normal" boy. After I met them, they gave me so much support and companionship. ››

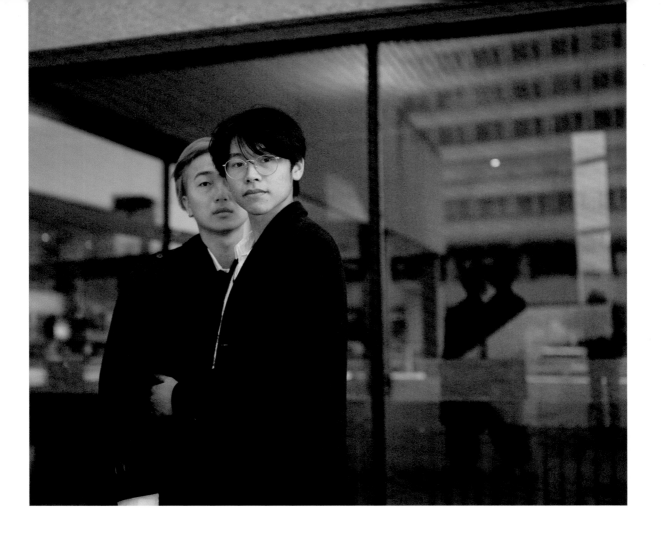

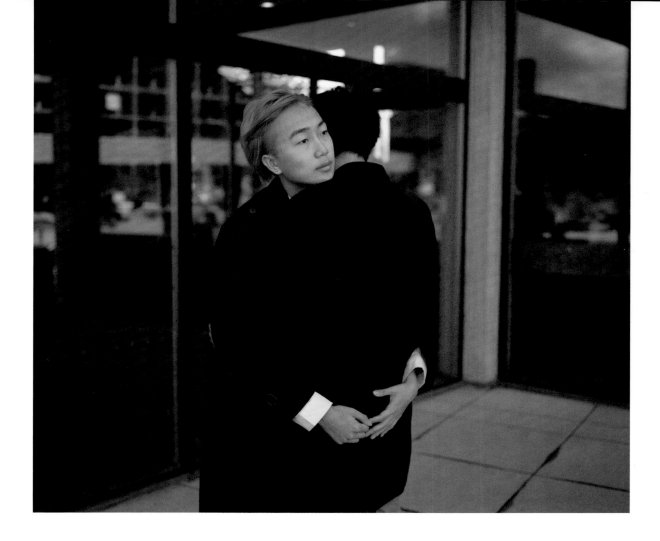

Chan Davey: I was born and grew up in the Netherlands with my Chinese parents and little brother. I had a pretty good childhood and I never had to worry about anything in life. I never really cared much about girlfriends or boyfriends and was mostly just enjoying life with my friends in high school. At one point I did figure out that I was attracted to boys, but I never really cared enough to actually do something with it. I thought that I was just asexual and aromantic, until I met my boyfriend. There's this one quote I read back in high school that quite literally describes how I fell in love with him. It goes like this: "I fell in love the way you fall asleep: slowly, and then all at once." Love to me is like this deep affection I cannot get enough of. Love gives me this secure and comfortable feeling that makes me feel really at home whenever I'm with him. Every single day feels fresh and happy, and our conversations never end, even if we have nothing to talk about.

Family to me is anyone I love dearly. Not necessarily romantic love, but love in general. My relationship with my family is pretty great. We talk every day and joke around a lot. We also fight a lot, but that's just what family does. Recently, my parents and my younger brother met my boyfriend and they were really accepting. Honestly, I have no real complaints about my family, I am very lucky to have great parents. 🏵

郑婷文
Cheng Tingwen

For me, love is a hazy concept. At times, it appears to be a tool used by people to manipulate other people. People might say, "I love you," but they can also hurt you in the way they "love" you. As I get older, I realize that this type of "love" is selfish and toxic. Mutual respect, in my opinion, is the foundation of "true love." If you love someone, you will feel at ease exposing your most vulnerable parts. I'm hoping that "love" will be a haven for me to seek refuge from the storm, a haven for me to build resilience.

I know one thing for sure: I don't want to be defined by my ethnicity, gender, nationality, or my sexual orientation. I prefer to define myself as a human being who believes that everyone should be able to express themselves in this chaotic world as they see fit. That's all I want to be. ››

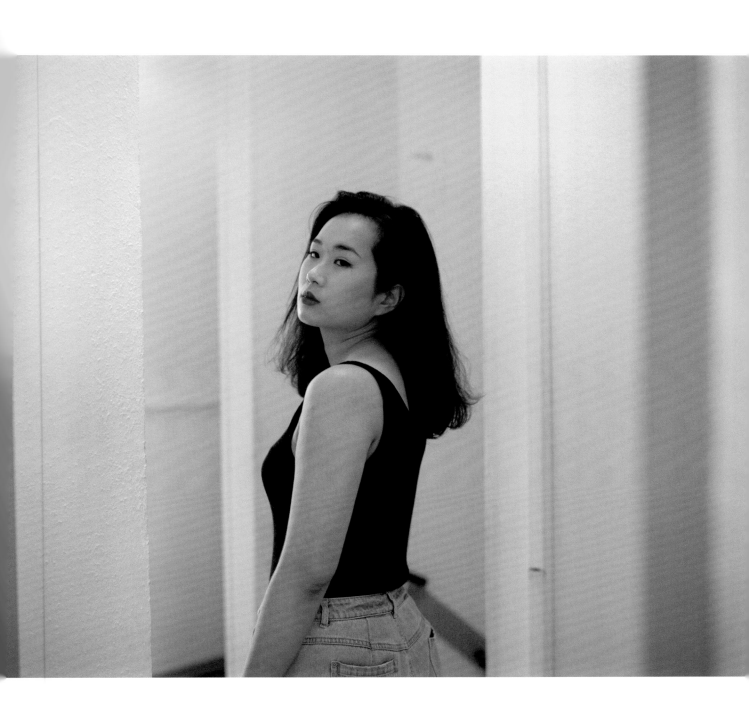

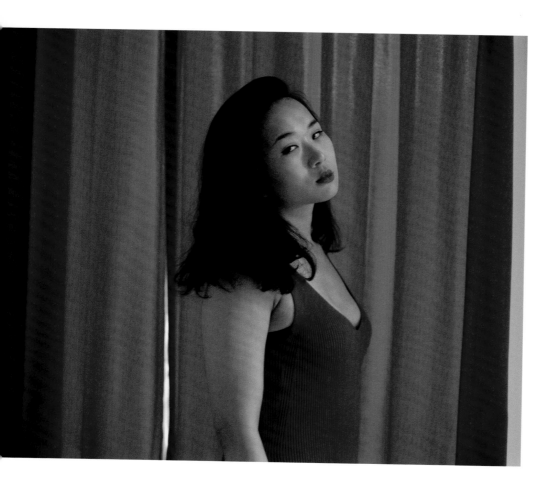

I dream of the day when I'm no longer restricted by my appearance and can freely roam the streets without fear. I'm content with the way I look. I don't think I should change; I think "they" should. I dream of the day when I'm no longer hearing stories of how to come out to my parents. Why do we need to come out to our parents, friends? Why not come out of your comfort zone and experience the world as it really is?

For me, family is a perplexing idea. My family consists of a father, a mother, and two elder sisters. We both adore and injure one another. Fortunately, the girls in the house have a strong bond. Particularly, my mother and me. We used to have a tough relationship during my adolescence; we simply see things from our separate viewpoints. However, as a result of my father, we, the girls in the house, have developed a strong bond. 🈂

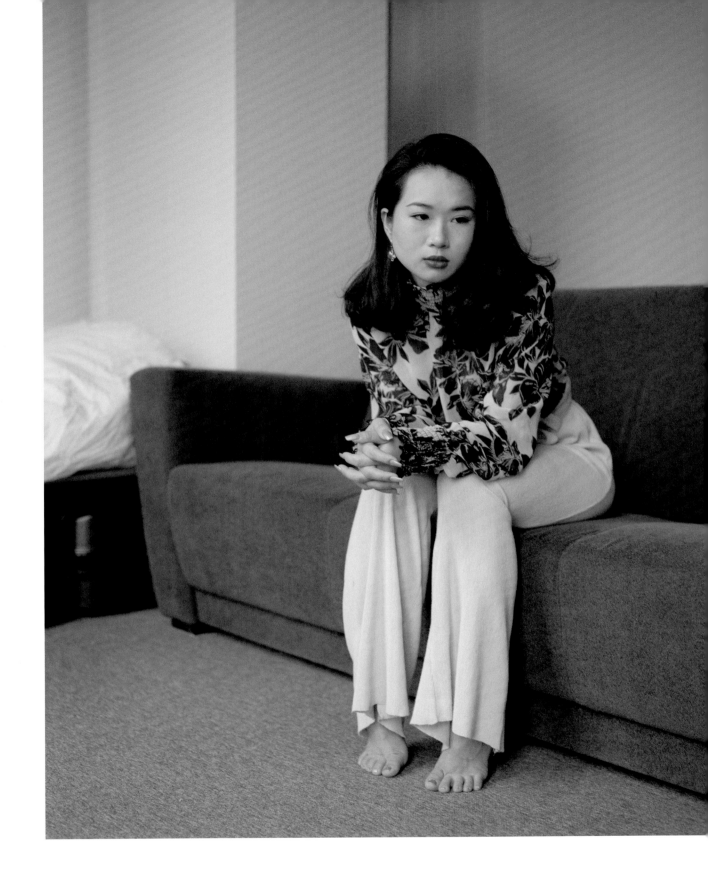

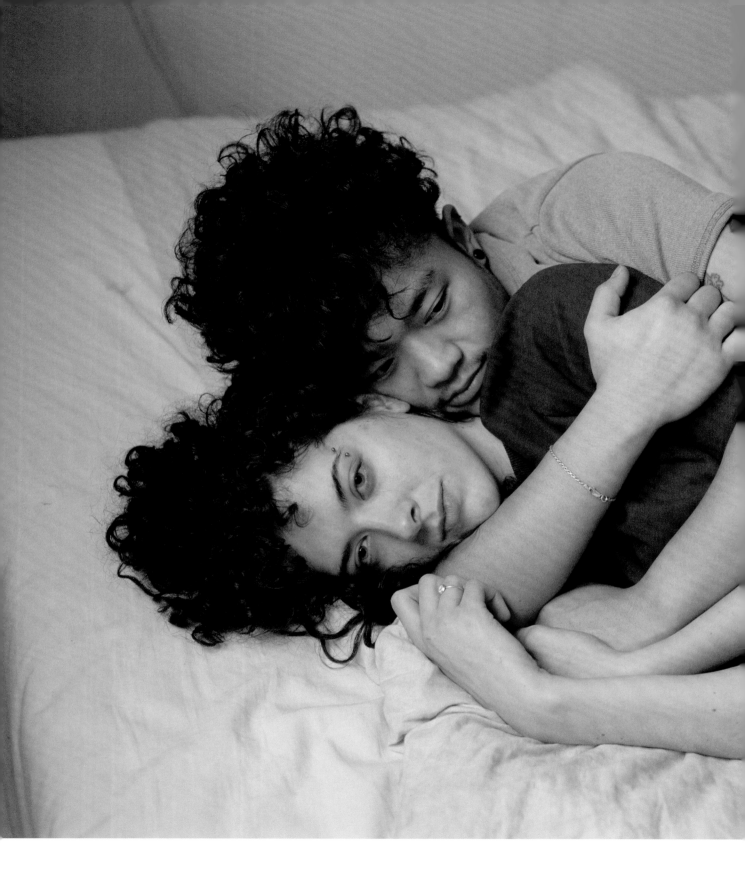

陳穎琪
Chan Wingki / Fleur Lidewey Goossen

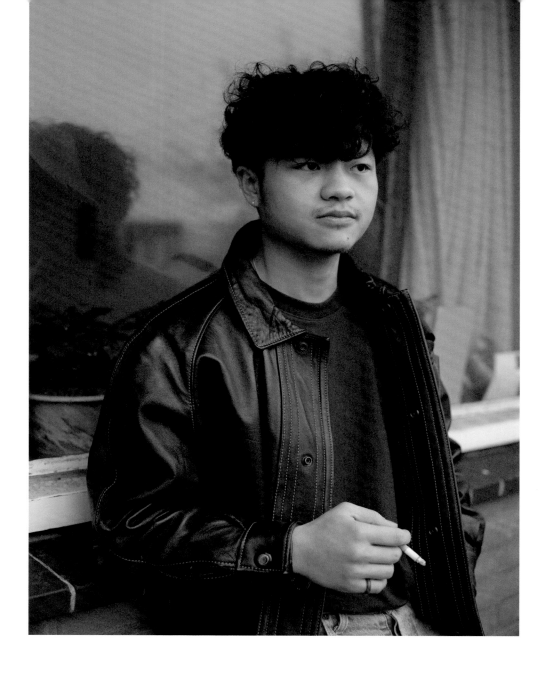

Chan Wingki: I identify as a man, a transman, a son, a partner, a friend, an open person. For me love means positive connections. It's about emotions, commitment, interest. It's about the positive emotions you get from your involvement with someone you love or cherish. Of course, it's also about negative emotions—the negative emotions you feel when the one you love is beyond your reach. For me, it has been a quest, finding out what love means to me. I do know that I have constantly been in search of it. I have found love in small things, like making coffee or the sun touching my skin, but I have also found love in giving love, creating a new connection. Love is dynamic, warm, addictive. It's also vulnerable and painful. In the future I hope to be able to do the things I love, with the people I love. I hope to meet new people. I hope that people are more caring toward each other, speak more with each other.

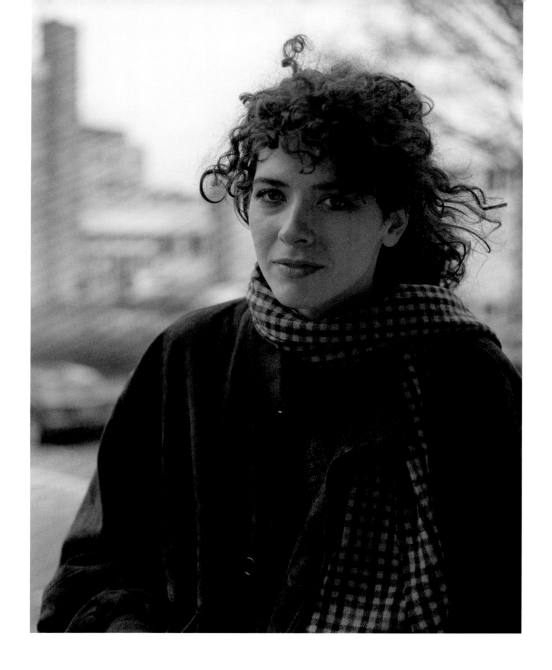

Fleur Lidewey Goossen: I have a lot of love to give. I think love can mean a lot of things. Appreciation, dependence, admiration, surrender, trust. Sometimes I think love is scary, suffocating. Other times I want to drown in it. I'm Dutch. I think and feel deeply and intensely, which I've grown to love about myself. Looking back at my life, I'm very privileged. I sometimes feel both guilty and grateful for it. I think I'm a late bloomer. I've always been an observer, which frustrated me for a long time. Now I think my observer qualities work well for me as I'm studying photography. Creating and learning about the [visual] arts has been incredibly fulfilling to me.›

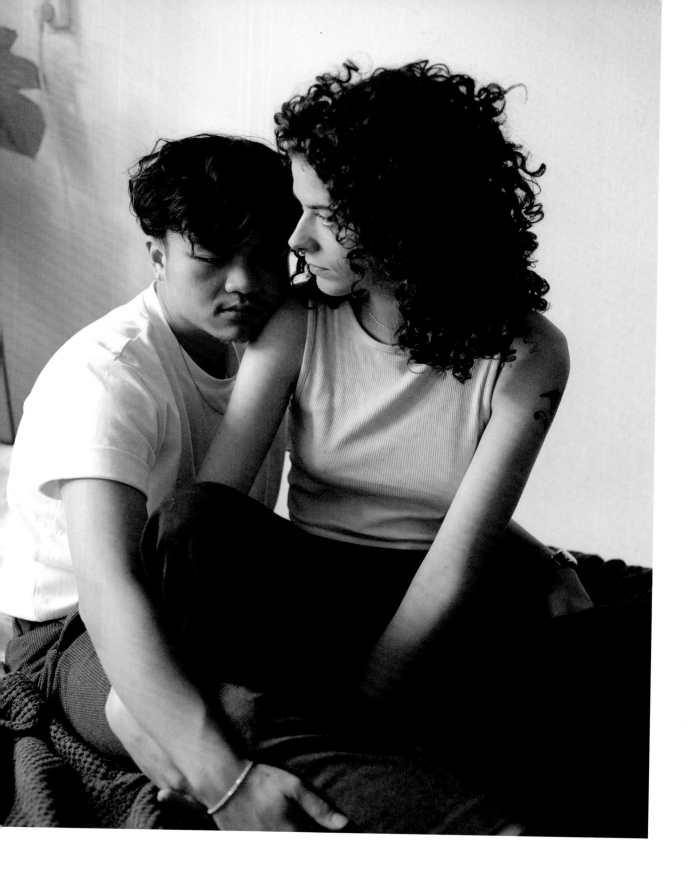

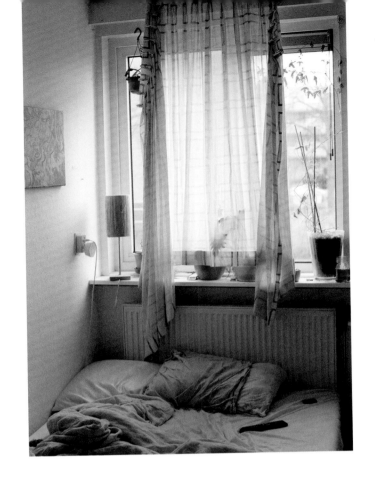

Chan Wingki: My Chinese name is Chan Wingki. I am twenty-five years old and I have lived in the Netherlands for fourteen years. Fourteen years ago, my father and I emigrated from Hong Kong. I am completing my bachelor's in psychology. It has been a very long journey to get to where I am now, both culturally as well as my transition. When I was fourteen, I announced that I identify as a man. This was, and still is, a difficult topic in my family. I don't speak to any of my family anymore. Society did not make it any easier. Today I am who I am, and when I look back, I am proud. The support of some people around me made this possible.

Fleur Lidewey Goossen: You don't get to pick who you are related to and so there should be no obligation toward family. My family has always been pretty distant toward one another. I am, however, close with both my parents. I have always looked, and still do, at my parents with admiration. As I am growing older, I feel like I'm just getting to really know my parents, as friends and "normal people." I see them as open-minded, curious, intelligent.

Chan Wingki: I have a complex bond with my family. I am part of a big family. Most of them live in Hong Kong. My connection to them is mostly through memory. They are not in my immediate surroundings. I grew up in a different way than most of my family, so there are now cultural differences, differences in norms and values. I have come to be more at peace with the fact that for me family is different. I value family a lot, but I have realized that family does not necessarily need to consist of blood relatives. The people who surround me, who care about me and whom I care about, they feel like my family. It's about unconditional love, not because I am somebody's child, but because of how and who I am. This way I also love people for who they are. My chosen family is the family I care for most. 🔠

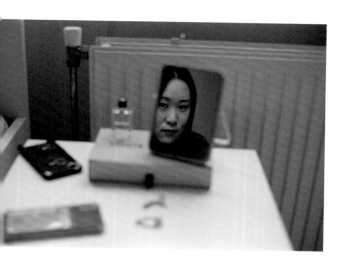

吕灿
Lyu Can

I think love is a way of communicating with the whole world instead of just a relationship with someone. We definitely will not die without love, but without it we will live boring and meaningless lives.

I like being female, both physically and psychologically, all the time, but I also realize that the definition of gender is so behind, so unenlightened. I prefer giving people the rights and freedom to define themselves in their own ways. I defined myself as a bisexual or lesbian during my youth, but now I think I don't have a gender.

I'm originally from China. When I was a child, I struggled with who I was. I was eager for answers, but once you have more experiences, both positive or negative, the horizon just gets broader. Feelings, suffering, they will not damage you. They will give you clarity.

Family is the most important part of my life. They are my rock, my backbone. I would not be whole without them. When I was growing up, my mother didn't understand how I was different from other, "normal" kids, and inevitably we argued about this. I suffered from depression in junior high school. Sometimes I believe that her denial was the source of the depression. Recently, she has started to accept me and to understand, occasionally. Our relationship has improved.

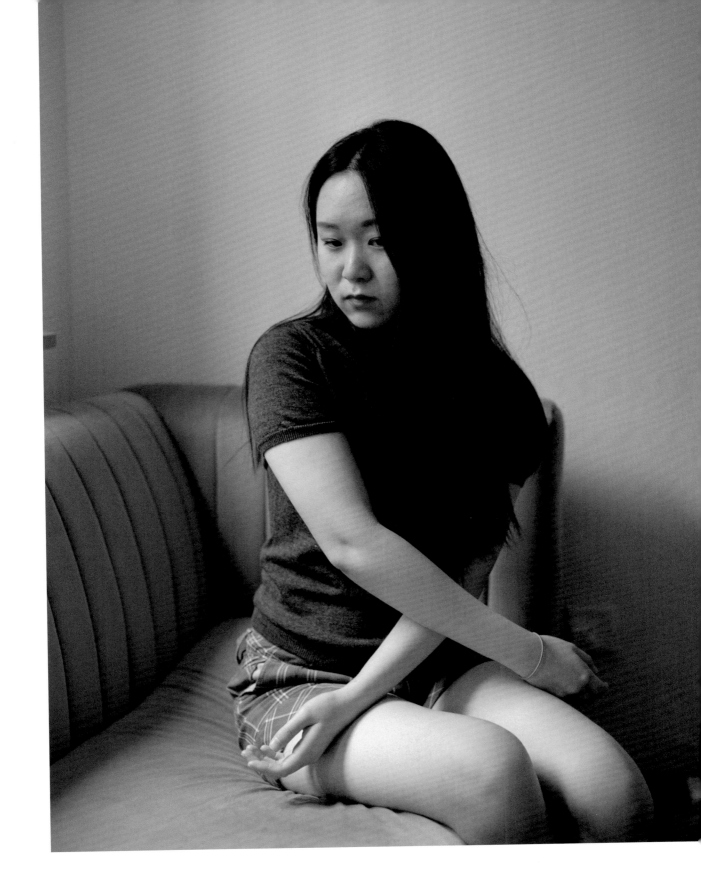

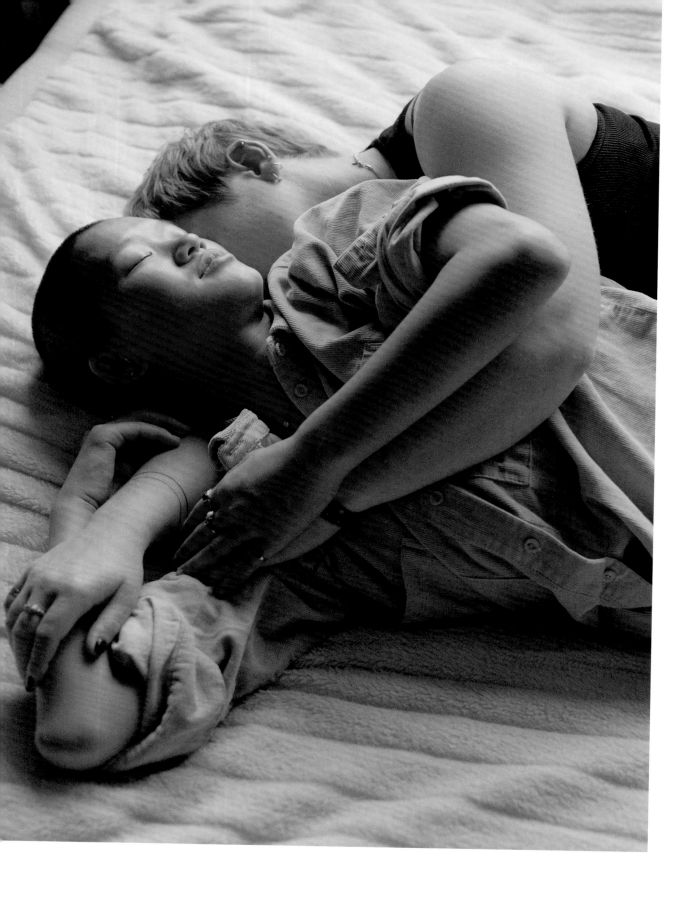

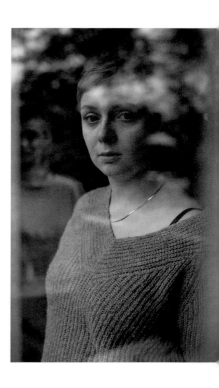

洪桃勇

Bo Taoyong Clavaux / Silke Goodjk

Bo Taoyong Clavaux: I don't even know what love means to me. I think that we can love people in different ways. We can love them for how they behave, for what they say, but also for just being there with you in the moment. For me, how I experience love in this relationship means being intertwined in each other's life by choice. Choosing to make a bit more effort in making each other's day, really listening to someone and just being together. I like the little things that come with love. Sitting a night in together, making jokes only you two understand and find funny, knowing each other's tells and most of all, making rituals together. ››

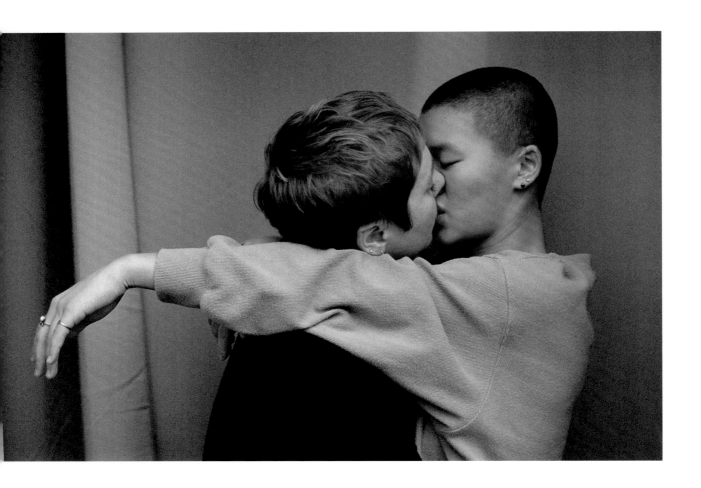

Silke Goodjk: Warmth; in every form and shape of love, warmth is the first thing that comes to mind. Whether I am talking about the love I share with my family, my friends, or my loving girlfriend, warmth is the feeling that I want to feel when I surround myself with someone I love. Though right now I have never felt so much love for someone as I feel for my girlfriend. It is scary, amazing, emotional, warm, and I just feel so blessed and lucky to have her in my life. I never really saw it take shape, this kind of love. I only had this big, dramatic image from stories. I am glad it is not like that. I love how all the small things are big in every way. When she buys me strawberries for breakfast, when I put dumplings in her freezer for when she gets home from work, how she gives me a kiss on the cheek randomly throughout the day, how I put extra chili flakes on her side of the eggs, how she gives me the large towel and herself the smaller one when we shower, but also how we talk about our future together even though the idea scares the hell out of us.

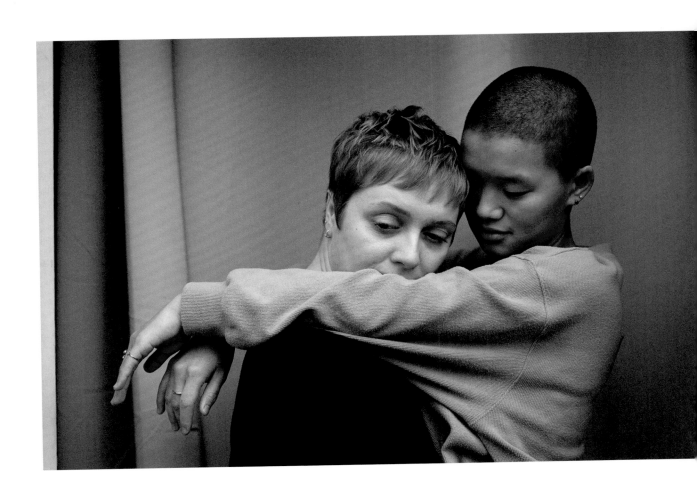

Bo Taoyong Clavaux: I was adopted from Nanchang, China, when I was two and a half years old. I can't remember what my life was like back then. What I do know is that I was very strong-minded. I protected what was mine, tried hard to get my way, and was closed off to many people. Moving to the Netherlands with people I couldn't talk with because of the language barrier, in a town with mostly white people, shaped me into the person I am today. I have learned to stand up for myself because of bullying. I am very passionate and driven to succeed in many things. But I am also sometimes very hardheaded, can get very pessimistic about everything in life, and question the importance of my own existence. I am glad to have a few really good friends to whom I can tell everything, and have been given the opportunities to study and enjoy doing things I like. ››

Silke Goodjk: We met in July 2020. Since then we've spent so much time together. We met through Tinder. I was planning to have a lot of sex with a lot of different people. Obviously, that did not happen. Our first date was going for drinks for about an hour or three.

> **Bo Taoyong Clavaux:** It was during the pandemic. The lockdown was just partially lifted and we met in a café for an hour or two.

Silke Goodjk: She had another appointment that evening with a so-called friend, which later on I heard was a sex date. I really like this detail now about our first meetup. A week later Bo texted me that she was bored and asked me over. Obviously, it was a booty call, but even though we both knew that, we ended up watching Netflix, dancing to Sam Smith's "How Do You Sleep," and just having fun. It was around 5:30 in the morning when we finally kissed and, of course, had sex. After all, that was sort of the setup. Since that night and morning, we kind of saw each other whenever we weren't working.

> **Bo Taoyong Clavaux:** I am really happy with her; I can't imagine my life without her. I am afraid of so many things. I am afraid of not fitting in, being treated as an outsider. I always look really comfortable with myself with an attitude of "I don't care what you think of me," but I do. I am afraid of not recognizing other people's emotions and being scolded for it. I am afraid of being seen as ignorant, cold, arrogant, or uninterested. I want people to see that I care about them, about what they do, how they feel. Because feeling like no one really pays attention to you is horrible, and I wouldn't wish it on anyone. Maybe that's what I am most afraid of—people not paying attention to me anymore and me being left all alone again, just like when I was abandoned on the street in China. Being left alone without anyone to care about me and to otherwise die. 🔲

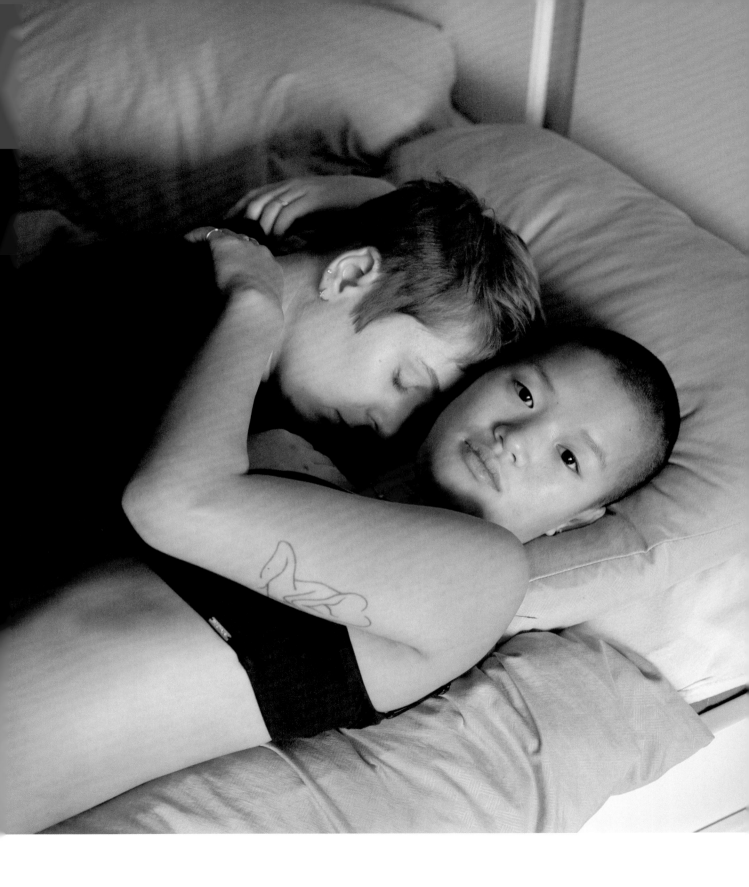

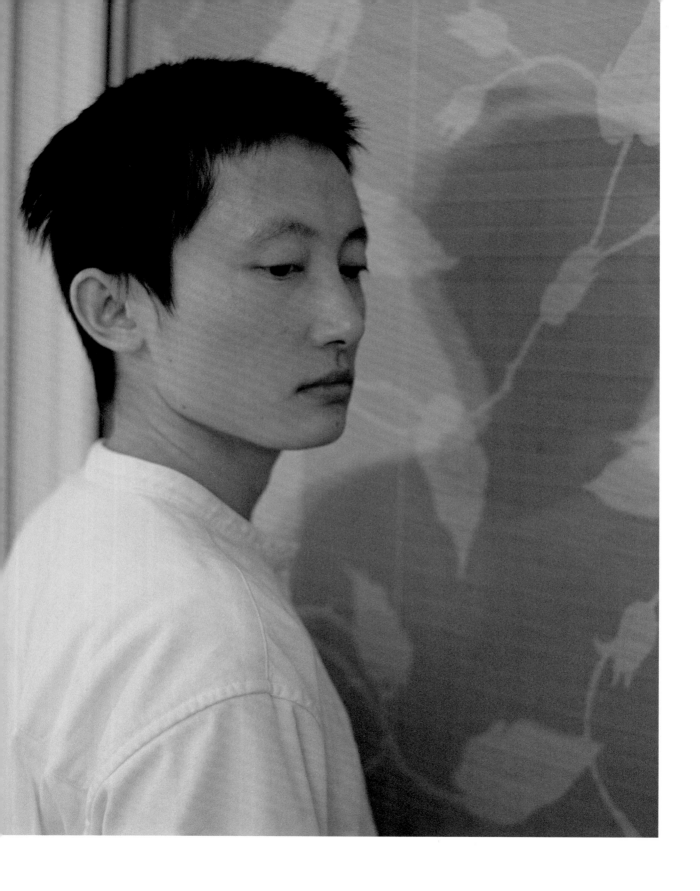

任盼
Ren Pan

On falling in love, your body enters a sort of zone. It's a profound occurrence that transcends time and space. You feel pangs of emotion even as you look within yourself. Love can spark creativity. It can be exclusive or inclusive, accommodating various possibilities within a loving relationship. Its effect on you might be full of contradictions, for it can either dissolve or expand the zone of self. The person you love, especially her charming qualities, can become part of this zone of self. She too can engage in this journey of self-transformation. ››

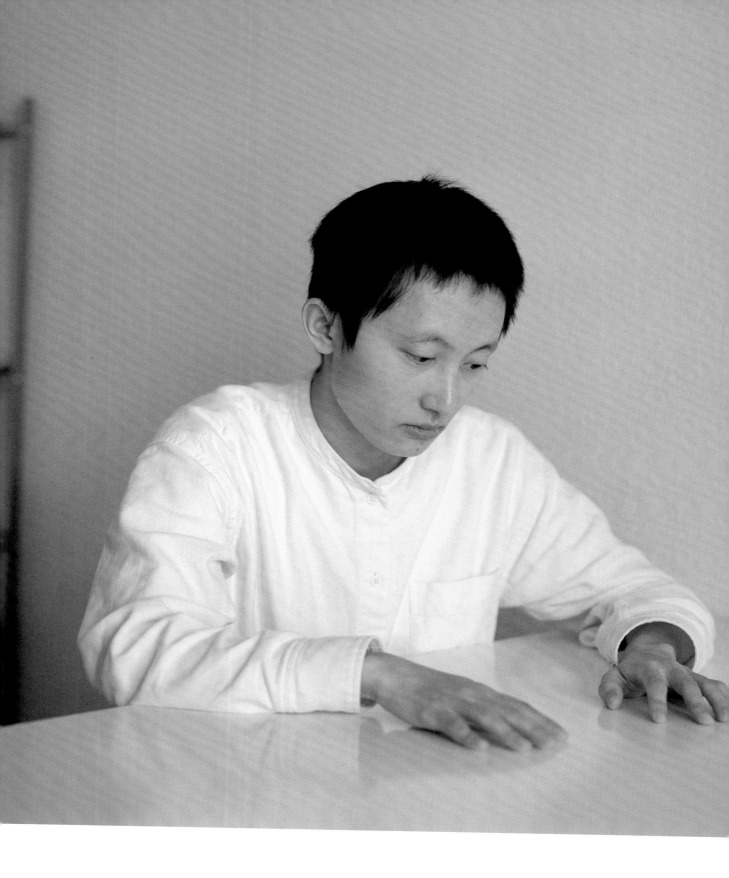

How do I identify? The simplest answer might be: I like girls; my biological sex is female; my gender identity is nonbinary; I'm queer. But I want to add another layer. I've attempted multiple times to ask a friend whether she likes boys or girls. Once, when we had a brief online discussion about our understanding of love, she said that what attracts her transcends gender and race. Ever since that conversation, at least when talking to her, I've shed the trendy vocabulary around identity that I'd been using. When we met, I saw that she'd assess a situation, focus on specific moments that moved her, highlight details that were important to her, and would tell people about those. She shared her passion this way. When I searched my own memory, I recalled the different conversations I've had with her and I saw her subjectivity—enveloped in love, constantly absorbing light, and always growing—emerge, a personhood that encompasses faith, courage, openness, joy, respect, and moderation.

I have an older sister. We have a lot in common—including our attraction to women. We are similar in age and life experience. We support and confide in one another. I'm not the one who initiates conversations, but when I listen to her or give her my advice or opinions, I can indirectly experience her life, which enriches mine, so much so that certain decisions I make in my life are influenced by her. Whenever I compare myself to her, I discover the differences in our personalities, thus deepening my understanding of both her and myself. ››

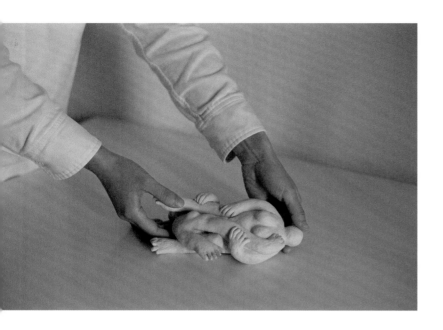

We grew up in Wushan. My parents have worked in the restaurant industry in the city for nearly thirty years. My sister and I, after graduating from high school, took a bus to Chongqing for art school. Later, I flew to Germany to continue my art training, while my sister flew to Shanghai to work for an online media company that produces popular science videos about sexuality and gender. While we are physically separated and oceans apart, we continue to exchange our thoughts and feelings, including our love stories, breakups, gender-related issues, work, hobbies, schooling, thoughts on foreign culture, and family updates through social media using text, voice messages, emojis, GIFs, and video calls.

My family bought a computer while I was in the first grade of junior high school. My sister discovered an internet celebrity on Wretch, a Taiwanese social networking platform. One afternoon, she wore a mysterious look as she told me—I was reaching puberty at the time—that she wanted to show me a picture of someone, betting that I could not possibly guess the person's gender. I gazed at the screen, wondering why the person's chest was so flat. Although I had never heard of a "breast binder," I could feel from the bottom of my heart that this stranger,

separated from me by a vast land and a deep strait, must be a girl. Her Wretch handle was Yang Yang, and she became a symbolic bridge for my sister and me to share our thoughts on love and gender orientation. In the late spring and early summer of 2020, my sister sent me a private message on WeChat saying that Yang Yang is now an FtM, attaching Yang Yang's video on Bilibili that was made during her/his hormonal transition. After watching the clip, I was surprised to see the changes in Yang Yang's voice and facial contours under the effects of the testosterone. It also felt like I was meeting an old friend in cyberspace—I was excited and happy, with a hint of melancholy. Later that same year, my sister interviewed Yang Yang for her self-made media video program about the LGBTQ community. After the first wave of the pandemic had passed, my sister and Yang Yang met up from time to time—they both lived in Shanghai. Now that we're entering the postpandemic era, Yang Yang is back in Taiwan, and I have not returned to China for two and a half years. My sister sent me a text one day, saying she'd dreamed that I was back home. The message was accompanied by a smiley face with crescent eyes and a big grin. 🔳

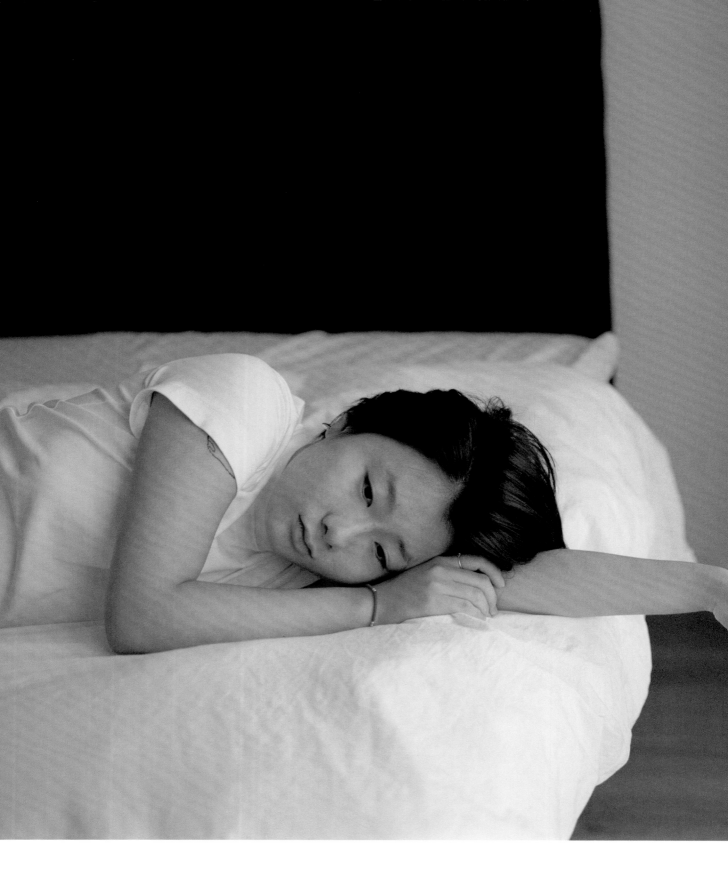

刘龙鑫

Liu Longxin

I prefer not to be labeled. It is not really because I want to be edgy, but mainly because I do not know how to identify myself. At first, I identified myself as a girl. Growing older, I assumed I was 100 percent heterosexual, because, well, it is the default in society, right? However, thanks to my mom, who is open-minded to some extent and progressive most of the time, I had already known of the existence of gay people (not really LGBTQ+ group, though) at that point. When I was in high school, I liked a girl. I liked her just because she was who she is, having nothing to do with her gender. Anyway, I figured I might be bisexual. I have since had more chances to know who I really am, more time for self-recognition and having conversations with myself. If you really want me to identify myself now, then I would say I am pansexual and asexual sometimes due to the fluidity of sex. I can love anyone regardless of their sex or gender, just because of who they are. ››

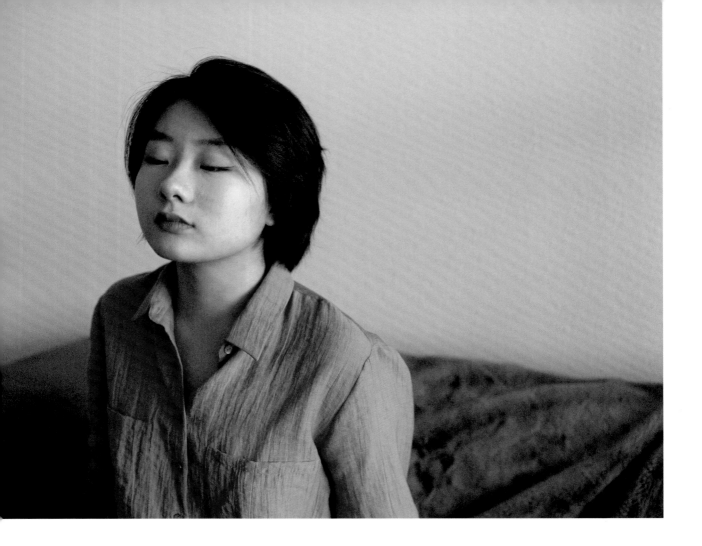

Speaking of difficulties and challenges I have come across in my life so far, luckily, none of them has beaten me. That is why I am still here and becoming who I am today. I am the only child and my parents are always busy, so I had a lot of time to get along with myself. My parents sent me to different summer camps when I was young, which has cultivated my independence. When I was eleven, I went to the United States alone and spent quite a while there; I also went to Nepal alone for voluntary work after finishing my high school. I took a gap year last year and stayed in Beijing alone doing my internships, etc. Each experience brought me something different with meeting people from different backgrounds. They made me learn to think deep, learn to look at this world from another perspective, respect others, and be more inclusive.

Honestly, my relationship with my family is completely like a roller coaster, which is probably because I inherited a bad temper from my parents. Most of us are emotionally unstable, which I am working on right now, so it is inevitable for us to hurt each other unintentionally sometimes, even though I still love my parents. I know they love me deeply and they would like to do anything for me undoubtedly. They are always backing me up, and I clearly know they will always be there for me when I need someone.

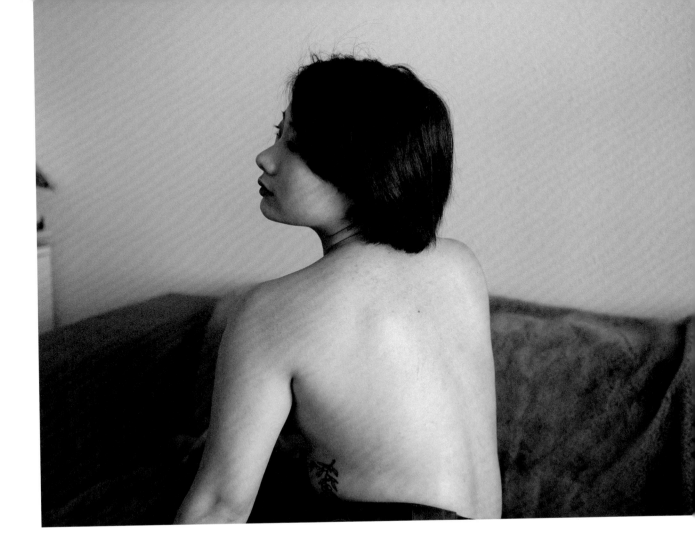

I used to blame my parents for my childhood trauma and insecurities. I also used to hold a grudge against them because they did not understand me. Now, I realize maybe I should show more understanding to them. They are human beings as well, they also make mistakes. It is their first time to be parents, and they also need time to learn how to become good parents and adapt to their changing roles over time. We should give each other time and chances.

Honestly, I feel blessed to have them as my parents. They gradually know how to respect me more and they understand that I am independent individual instead of being attached to them. Unlike most Chinese parents, they do not really mind if I get married in the future or not. They just wish me to be happy. They told me they would not push me and respect my choice. Actually, they lowkey do not want me to get married. They also said they would not force me to do anything now because I have my own life and they also have their lives, and the only thing they could do is stay healthy in order to accompany me for a longer time, which makes me want to cry. Just thinking that they would pass away and leave me really makes me sad. I love them so much. Seriously, I really have no idea what I would do if they left me alone. ⌘

张佳欣
Zhang Jiaxin / Kim Horn

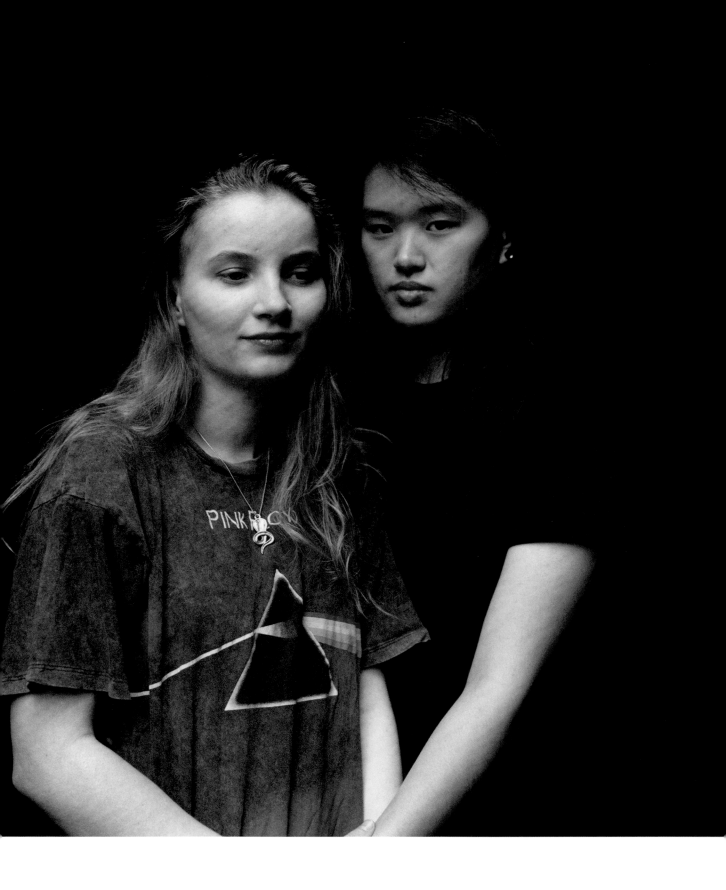

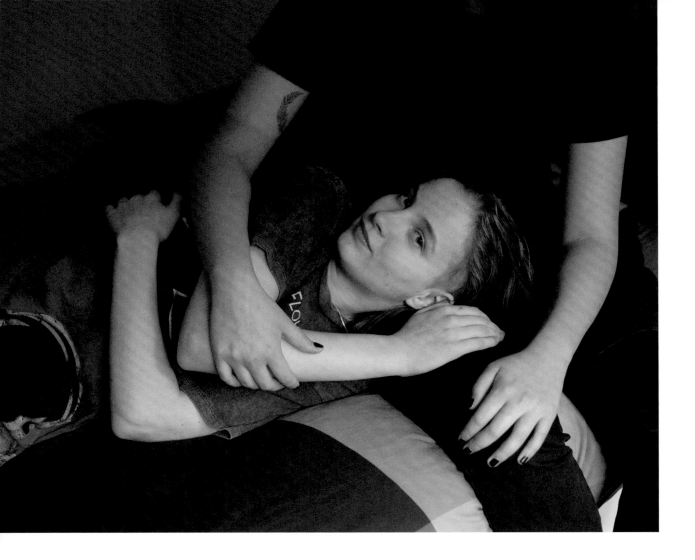

Zhang Jiaxin: Being loved and being able to love who I want is incredibly important to me; it's indescribable. Loving someone is valuing that person more than you value yourself. It is one of the most beautiful things in life but also one of the scariest. When you love someone, you show them all your flaws, while at the same time you put faith in them not to abuse that power.

> **Kim Horn**: Love to me means being completely comfortable around someone. Love is spending days together and never getting tired of it or wanting to go home. Love is not wanting to go to sleep so you have a little more time together.

Zhang Jiaxin: I was born in the Jiangsu province and lived in an orphanage in Zhangjiagang. At around ten months old I got adopted by my now parents and moved to the Netherlands. I lived in a small town for a long time and I would like to think I had a pretty happy childhood. A couple of years ago I moved out so I could start studying for my bachelor's degree, which is where I am at now. My biggest dream is to find a job I really enjoy and to settle down in a nice house or apartment. It might be a bit old-fashioned and it's not an absolute necessity, but I would like to get married someday.

Kim Horn: I was born in Maastricht in the Netherlands, and I've lived in this country for most of my life. I grew up with both of my parents and my brother and I had a very happy childhood. After high school I moved out to study game development, which is what led me to my job right now. My biggest dream has always been to travel and live in different places. I love learning about other countries, cultures, and how the people live there. It's not a necessity, but being able to call someone my wife does sound great.

Family to me means the people who will support me through everything. Being home with my family relieves a lot of stress, because I don't have to face anything alone. My parents are always there to help with whatever problems I run into. I have a very good relationship with my family and I feel very lucky to have such supportive and amazing parents. »

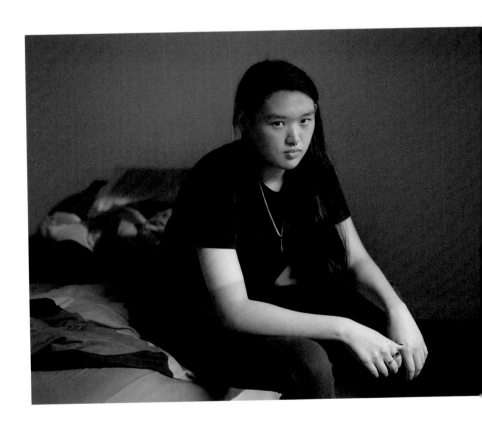

Zhang Jiaxin: I feel like a family loves and supports you, especially through hard times. For me this definitely goes beyond being related to someone. I see my family as the people I care for the most, so I consider my close group of friends my family, too. For clarification, I see my chosen family as my actual family, and I don't think my opinion on this matter would change even if I wasn't adopted. The relationship I have with my relatives is fifty-fifty. My parents have been divorced since I was very young. I lived with my mother and saw my dad on the weekends till I turned eighteen, which is when I moved in with my dad. I always had a rocky relationship with my mom and recently cut all ties with her, so we aren't on speaking terms. My relationship with my dad and his part of the family is really good. I adore my grandparents and always visit them whenever I'm at my dad's place. I have an amazing relationship with my dad, for which I will always be grateful. I feel like I can always talk to my dad without judgment. 🀫

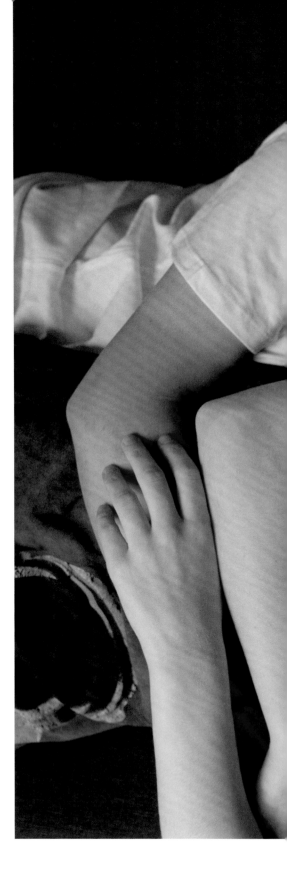

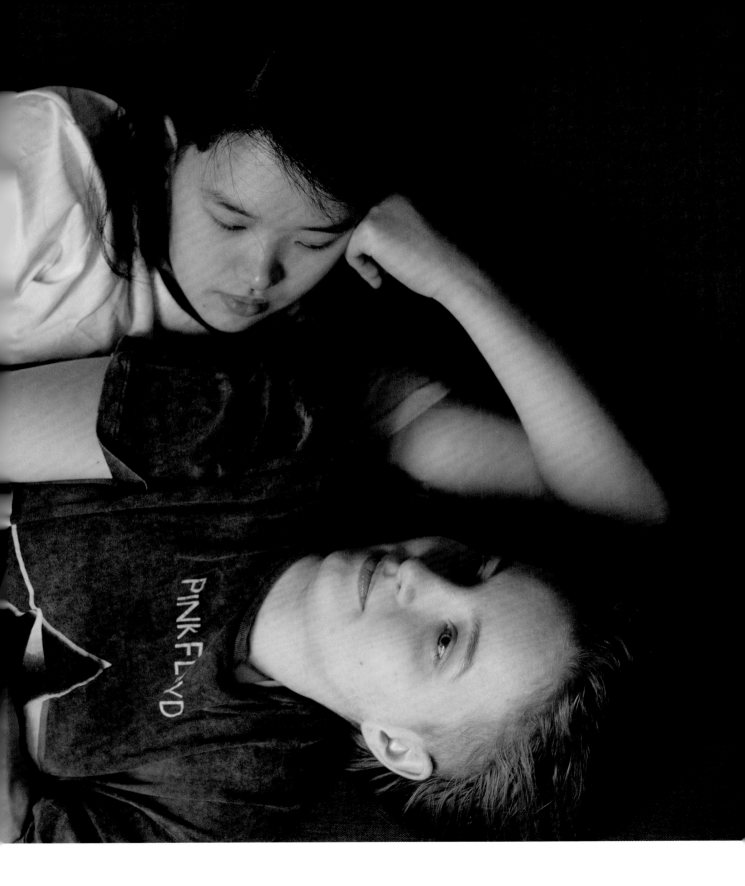

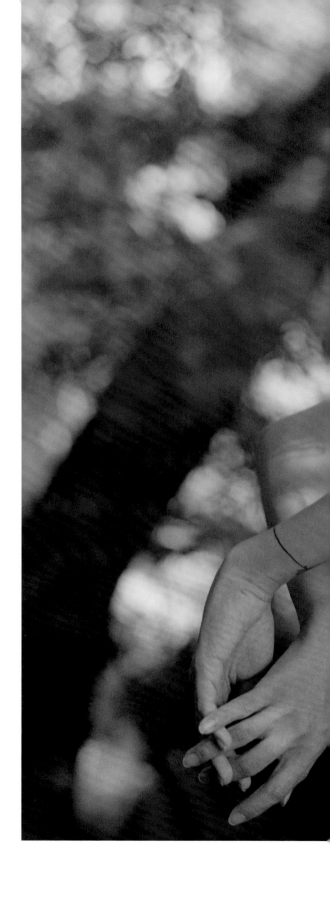

王志奇
Wang Zhiqi / Zhao Liang
赵亮

Wang Zhiqi: We've been together for 714 days. We met each other through WeChat. The senior female cheerleader on my college's cheerleading team was my boyfriend's classmate; he saw me in a group photo she'd posted on her WeChat Moments. He asked her for my WeChat ID; we added each other and became friends. We talked on WeChat and grew close. I sensed that he could become an important person in my life. Our first date took place at the bar where he worked. When I finally met him in person, I liked the way he looked— so he quickly became my boyfriend! ››

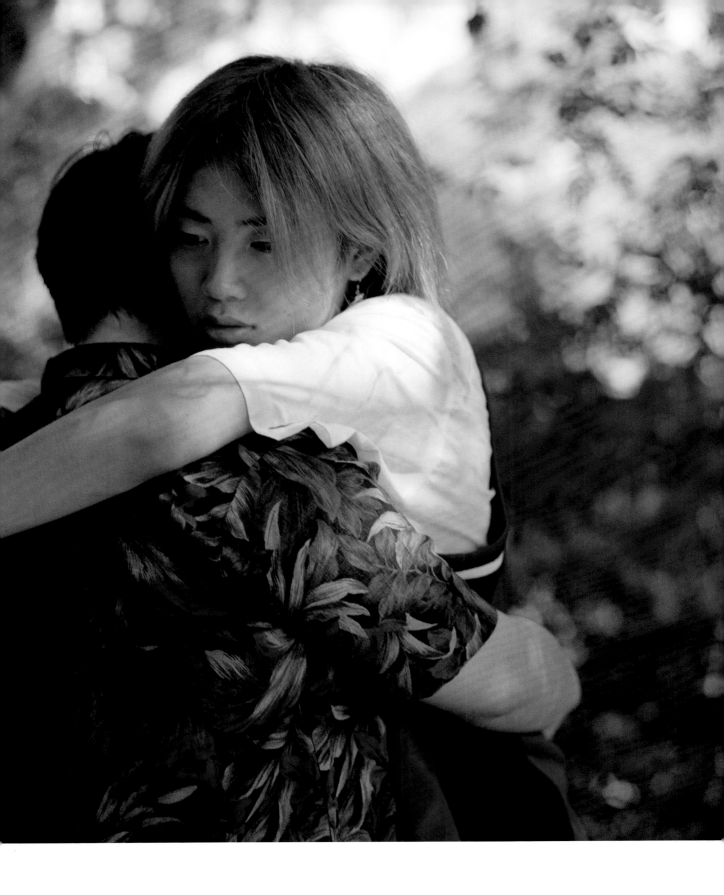

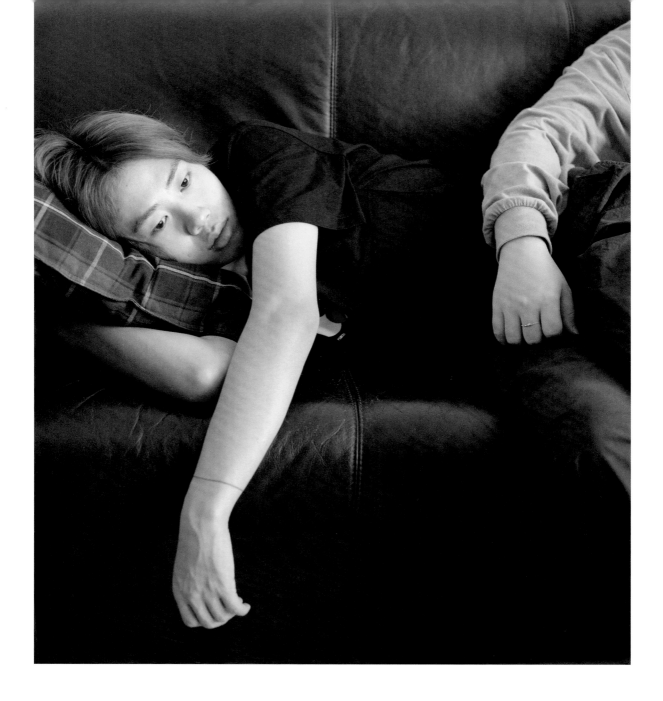

Zhao Liang: Since I'm his first boyfriend, and all my former relationships didn't go well, we feel we're both at the same level, learning how to be together, how to nurture our relationship, how to live in the moment while planning for the future, and, most importantly, how to better love each other.

Wang Zhiqi: For me, romantic love is the purest form of affection, an affection that brings me comfort and spontaneity. It's different from other forms of love like filial ties and friendship. In these other relationships, I feel like I'm playing a role that's both expected and acknowledged by other people. Only in a romantic relationship do all my emotions come from within; only in romantic love can I stay completely honest and true to myself.

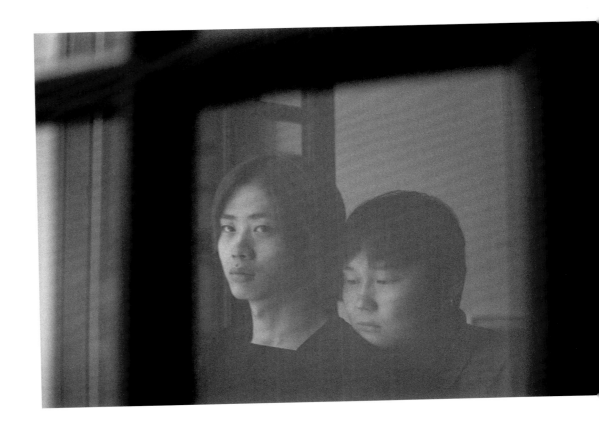

Zhao Liang: I used to say that love is a healing antidote. Often, I even feel that love is what sustains my life. But love is never utilitarian, nor is it an external force. Love illuminates life from within. It's often like a room with four mirrored walls. It allows me to see, accept, and embrace my infinite possibilities. Love softens and soothes my misery just as it multiplies my virtues and passions into countless reflections. And when I bring my lover into my room, love reflects numerous versions of "him."

Wang Zhiqi: I began to realize that I was gay in middle school, but I don't think this is permanently fixed. I identify as gay now, but I won't deny myself if my sexual orientation or gender identity changes in the future. I see myself as someone who craves change. In fact, I think I tend to avoid the process of understanding myself. Instead I dwell on a vague perception of myself. I hate analyzing myself and dissecting myself to show others what's in me. I might not be able to tell you who I am, but I hope we can see and understand me as an individual. Perhaps it's because I'm afraid to discover—once I've gained a clear understanding of myself—that I'm not as I'd imagined. Maybe I fear realizing that this lesser self can't be changed.

Zhao Liang: I was born in a small town in northern China on the border with Russia. In middle school, I had my sexual awakening and began to explore so-called "body art" websites; at the time, it wasn't very difficult to get hold of nude images and erotic films on the internet in China. One time, I saw a poster for Derek Jarman's film *Sebastiane* while I was browsing online. I didn't know what the film was about; I only read a brief description and saw the poster, which turned me on. But to my immense regret and disappointment, I couldn't find the film, but it proved that I was obsessed with the male body, even as a teen. ››

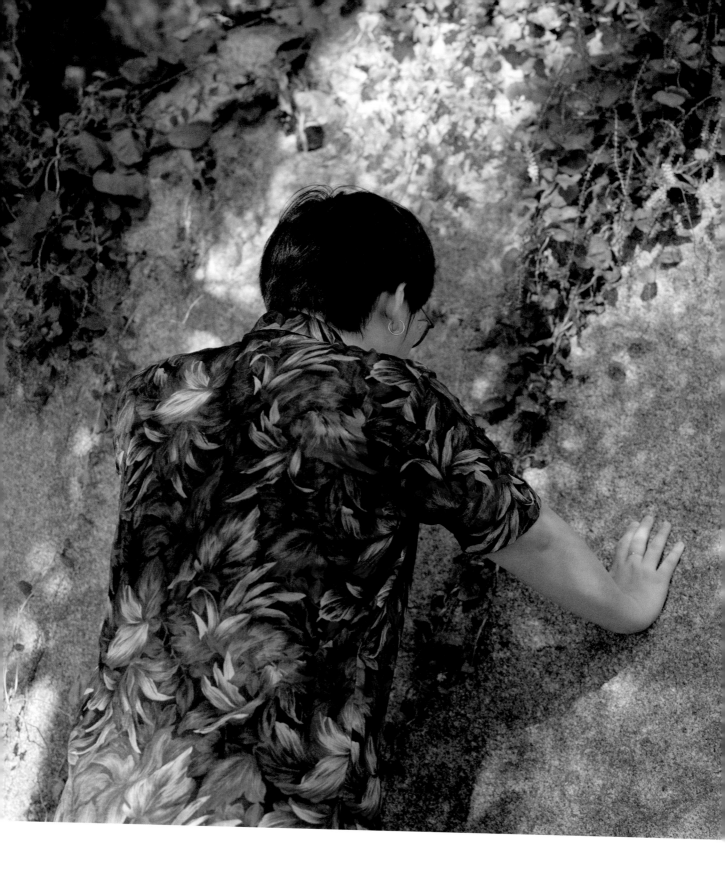

I wasn't so sure about my romantic preferences until I fell in love with a straight guy in my last year of middle school. It was the first time I felt so sure about love. I was passionate about him for almost two years—we went to the same high school as well. Later on, I fell in love with another straight guy. That was my predicament: the city I lived in was way too provincial, and there wasn't any well-developed online network available to help me find my community. I just became infatuated with the straight guys in my social circle—which only led to misery. That's one of the reasons I later became resentful of my hometown. I came out to the straight guys I'd fallen in love with. They accepted me, but we could never become lovers.

Sometime later, I met my first gay friend. Naturally, I developed some attraction toward him, but our relationship didn't go anywhere. I felt stifled in my hometown. I hated my feminine looks and my body and thought nobody would fall in love with me. My anxiety and doubt over my body continues to this day. ››

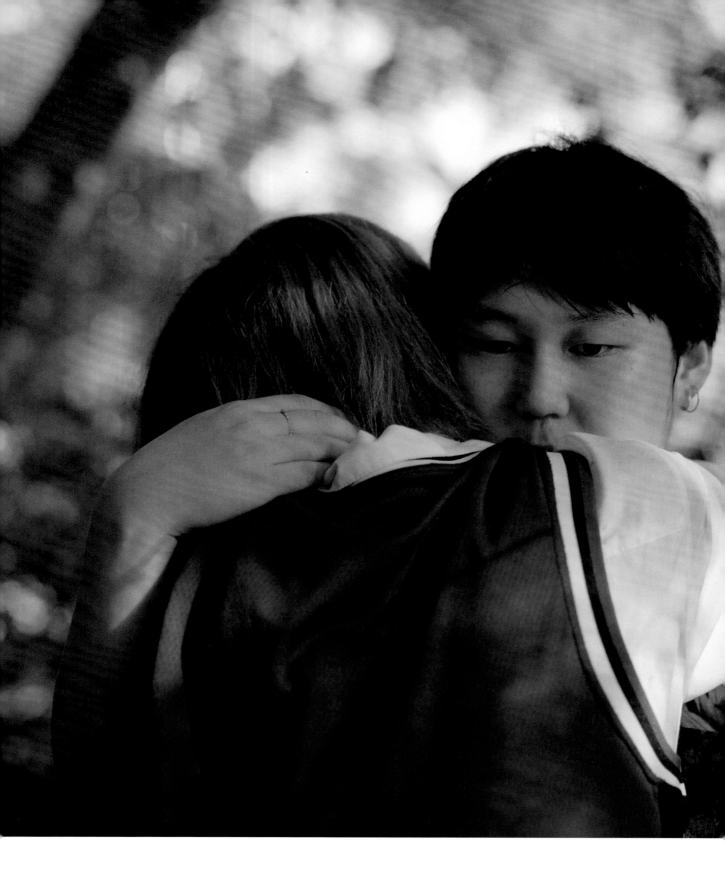

When I was younger, I spent most of my time at home watching lots of TV shows and movies. I have to admit that the queer characters in these films and TV series partly shaped my aesthetics and paved the way for my future studies. But I never had an intimate relationship before I became an adult, and my relationships always failed. I moved to a bigger city for college where I had access to a wider social network and began my first romantic relationship—but I'm still not very good at handling it.

When I started college, I studied humanities—Chinese literature, history, anthropology, and philosophy. In my sophomore year, I became more certain of my love for film. When the time came to pick a major, I chose film. I produced one short film every year in my sophomore, junior, and senior years. I was influenced by my own experience, and all my short films had queer elements—which was no small challenge at my relatively conservative college, where I wasn't allowed to participate in many school-sponsored film festivals. Luckily, my work was short-listed for the Beijing Queer Film Festival, which was encouraging. As for my future career prospects, I'll face greater obstacles and challenges to creating and distributing queer films in China. ›

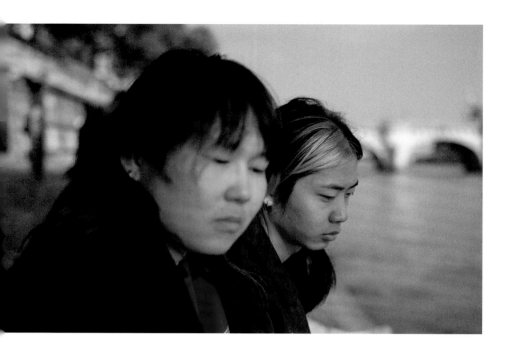

Zhao Liang: I haven't come out to my family yet. I feel guilty toward my parents. On the one hand, I know deep down that I will never have their approval. Once I come out to them, our relationship will dramatically change. On the other hand, I need their financial support to finish school, which is a heavy burden on them. I can't come out to them at the moment, although I have a bursting desire to tell them. I've always been different since I was a child. I was socially awkward, and I didn't meet my parents' expectations for a boy. To make me more masculine, my father tried to teach me how to play basketball for two years, but to this day I still can't play. Luckily, my father also likes music and film, and I went into the arts thanks to his influence. But I still don't feel like talking to him. I understand that he has very high expectations of me, which makes me even more afraid to tell him the truth—I fear that it will deeply disgust him.

My relationship with my mother is more complicated. I think she probably knows about my sexual orientation, but she's chosen not to believe it. The concept of homosexuality seems nonexistent for my family. Although I'm closer to my mother, and we can confide in each other at good times, we've also argued a lot and ended up in tears. I've never liked my mother making a scene. She was very strict with me. When I was younger, she never approved of me, my academic performance, or my other pursuits. But when I was admitted into a good college, my family suddenly became proud of me. To my mother, I'm more like a successful product she has poured her heart and soul into creating. Under her influence, I also have a strong desire for control, and I'm very irritable but emotionally fragile. »

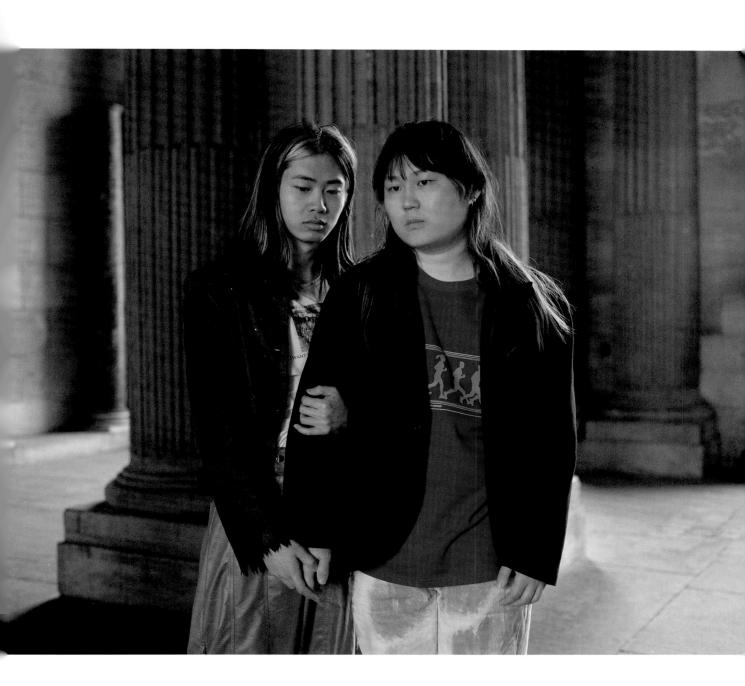

Wang Zhiqi: To me, family means an inescapable responsibility and a small source of warmth, which I believe comes from the stability of a family. I can't deny or avoid my relationships with my family members, who will always be my family. On the one hand, this means they will always love and care for me. On the other hand, it means I have an unavoidable responsibility to reciprocate their love. I find it difficult to describe my relationship with my family. I believe they love me deeply, but they don't know me, because I'm hiding part of myself and I don't think they'll ever put themselves in my shoes to understand me. So their love for me more often makes me uncomfortable. Considering I might come out to them one day, I hope to slowly distance myself from my relatives other than my parents—that's why I've acted indifferently toward these more distant relatives. As for my relationship with my parents, I feel even more at a loss because they've sacrificed so much for me. I know that if I come out to them in the future, they'll suffer even more for me. For this reason, I don't know what I should do to make up to them for what they've done for me.

> **Zhao Liang**: In the future, I hope to become freer as a queer person. I hope to continue pushing my boundaries and to gain a more nuanced and in-depth understanding about myself. I hope to become a creator. I also hope to become myself, to have my work recognized, and perhaps to win some accolades. I hope that my struggles are not for nothing. I hope I can repay my parents. 🏮

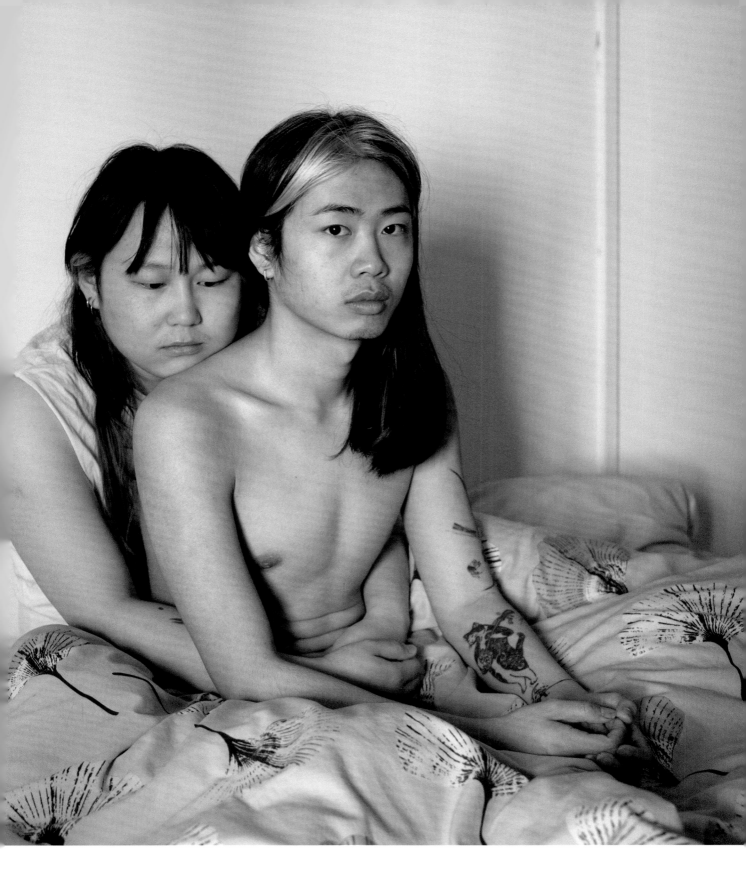

赵宝阳
Zhao Baoyang

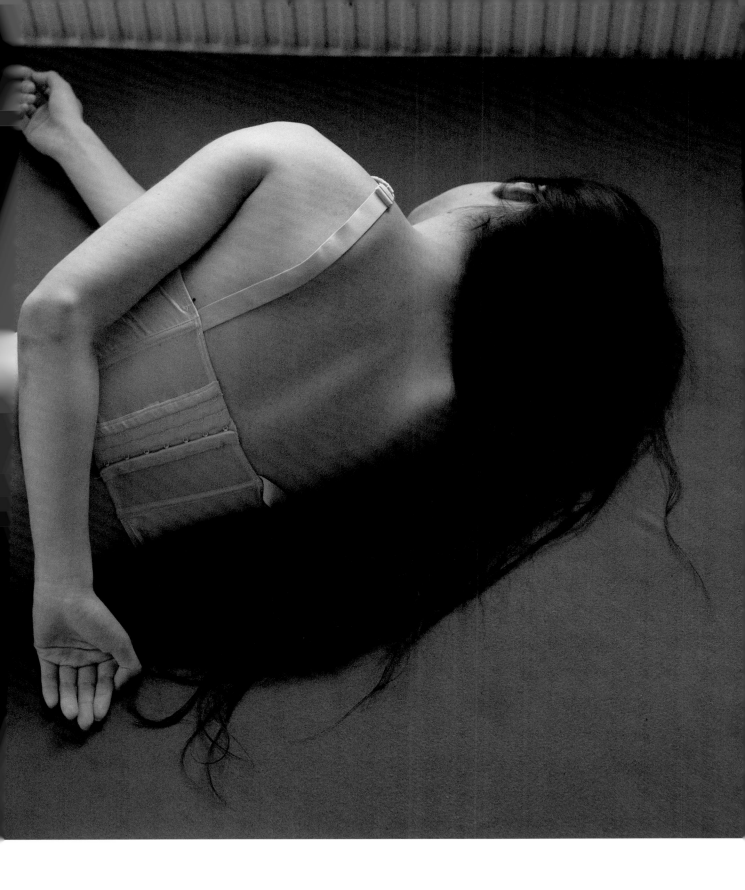

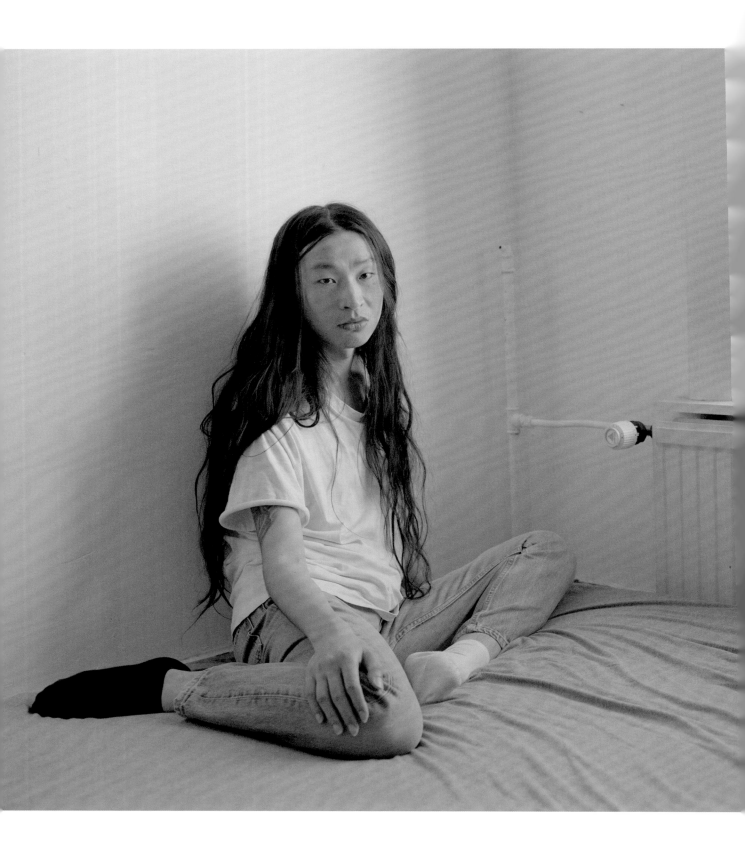

Love is ambiguous to me. In my understanding, it is a bonding and connection that can make people become unity from individuals. At the same time I feel I am way too independent to love people or be loved. I realize more and more that I am good at understanding people but not so good at loving people. Love doesn't need understanding from both sides. It needs devotion and a certain stupidity which, in my opinion, not only links to the romance of the love tragedy but also is the beauty of humans. ››

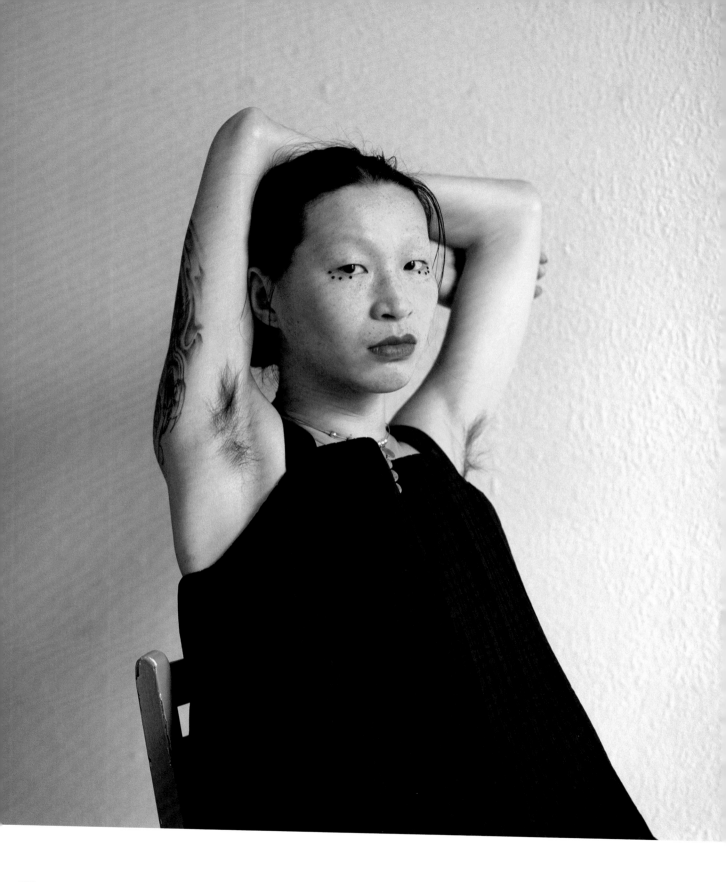

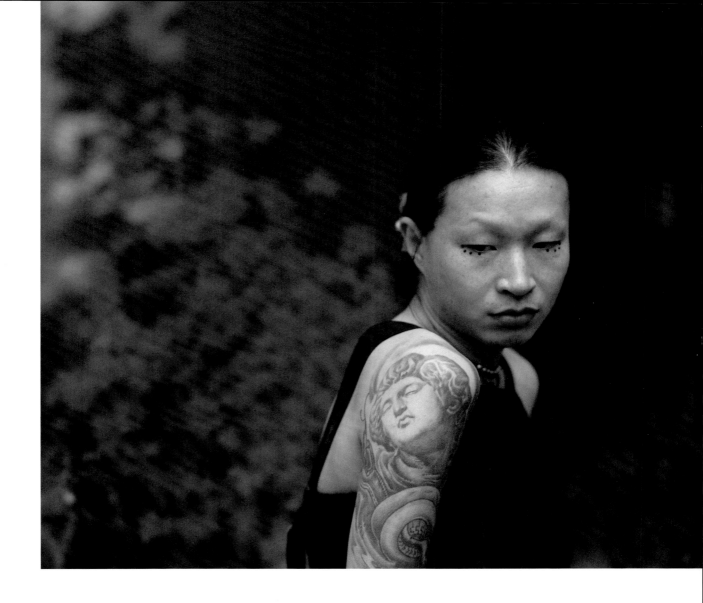

I want to be pretty no matter in a male way or female way or nonbinary way. I don't define myself by gender or sex though I experience the misunderstanding by people based on my appearance. My background and my experience shaped my character and my identity. It is certainly linked to my sex as male because I am treated like one, but it plays a less and less important role in my identity now. I focus more on what I read and what I think, about the things I am interested in, which reflect who I am inside and not my gender.

I am normally not afraid of much. I realize that sometimes certain things or situations are out of my capacity to handle or even understand. I also accept most of these situations. I will feel happy or sad or pain or disappointment according to the situation but not be afraid of them, but I do feel fear when it is about things or people I care about. 🔲

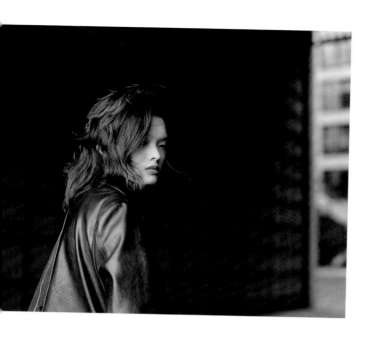

洪可欣
Hong Kexin

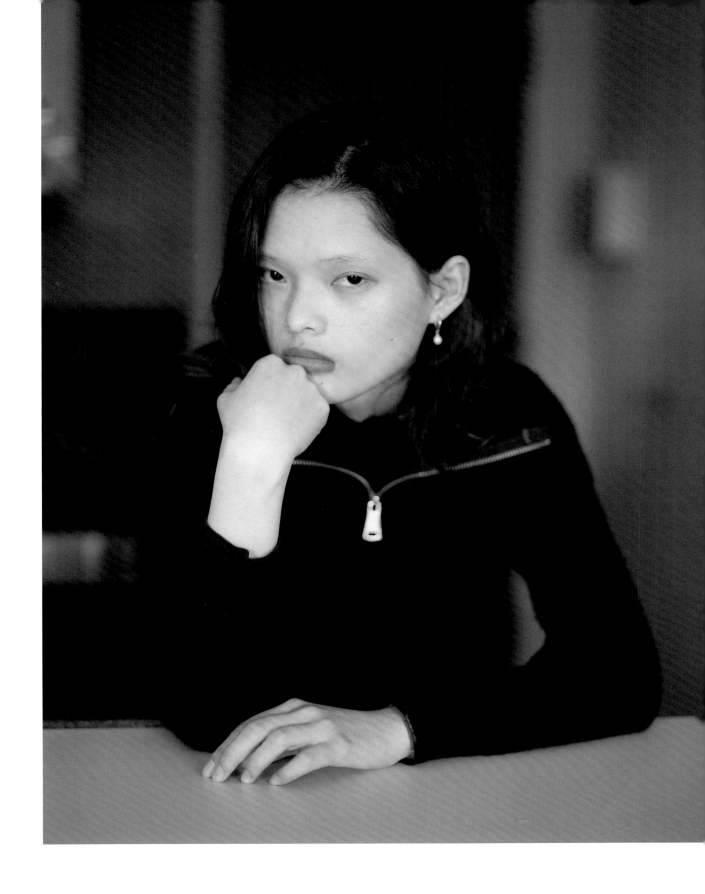

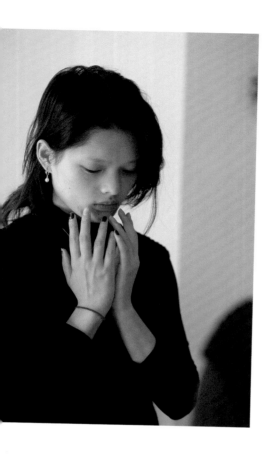

Love means constantly discovering your other personality hidden in the unconscious. Love means fragility and strength.

When I was a child, I knew I loved art, but at that time, my parents didn't support me, because they were prejudiced against art. Being myself is my issue in life. I'm afraid of myself. I am my own highly competitive enemy. I'm still working on bettering myself, so everything is unknown yet. I don't have any expectations for the future, because I always thought every day was the last day of my life. If there were expectations, I would hope that I could create artwork that I am satisfied with and meet someone who loves me honestly. ››

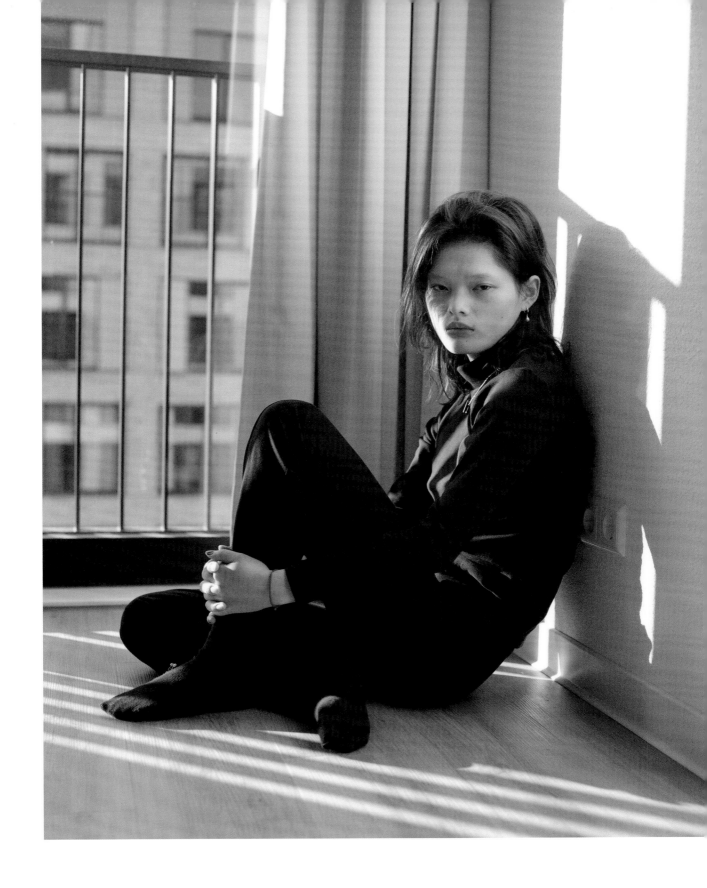

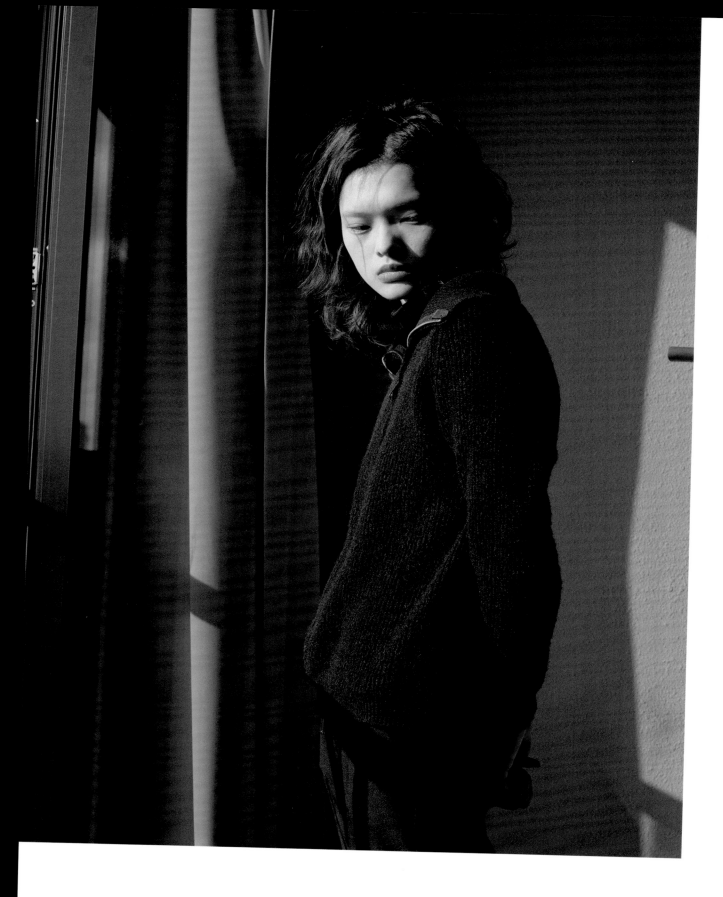

For me, my family is the petri dish of my soul. It influences my personality, the way I conduct my life. My parents got divorced in my childhood. I remember when I was a child my mother always lost control of her emotions. Most of the time we ended up arguing with each other when we wanted to have a conversation. There is an invisible gap in the relationship between my family and me. But I know I love them from the bottom of my heart; I've never told them, though. 器

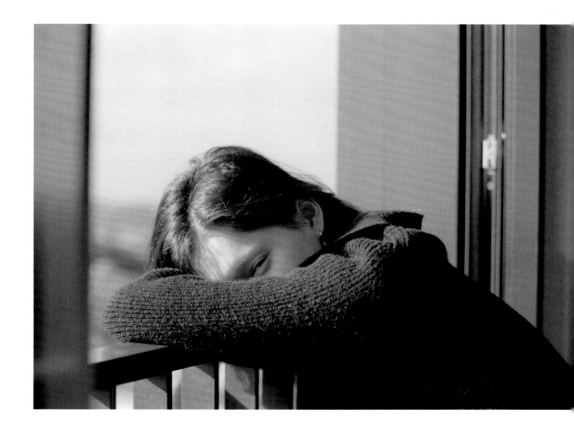

Acknowledgments

The photographs presented in this book were made possible by Jon Stryker: philanthropist, architect, and photography devotee.

This book was made possible in part by a grant from the arcus FOUNDATION*

I would like to start by expressing my sincere gratitude to the thirty-one young people (living in China, Netherlands, Germany, and France) who I met and got to know while working on this photography project. I am grateful to have met such generous, brave, and special people participating in this project. I was deeply touched by their openness and trust, and by the fact that they were willing to share their personal stories with me.

Thank you:
Xiaoli & Zhemin, Chen Ze, Caixia, Kaisen & Kairong, Feifei & Lu Ling, Yaoda, Ke Qian & Cai Peijing, Mingway, Hualiya & Xiyun, Zhang Lu, Zhaohui & Davey, Tingwen, Wingki & Fleur, Lyu Can, Bo & Silke, Ren Pan, Longxin, Jiaxin & Kim, Liang & Zhiqi, Baoyang, Kexin, XiaoXiao Xu, Haiqing Wang, Xiaoyu Dou and Liyao Yu.

I would like to thank Jurek Wajdowicz, Lisa LaRochelle, Yoko Yoshida-Carrera, Anna Fangan Xu, and everyone else at Emerson, Wajdowicz Studios for believing in my work and for giving me this amazing opportunity. And for the great collaboration and for making the best book.

Thank you Chen Chen for the beautiful and tender introduction for *Solace*. And thank you to Ben Woodward and everyone at The New Press for making this book a reality.

*The Arcus Foundation is a global foundation dedicated to the idea that people can live in harmony with one another and the natural world. The Foundation works to advance respect for diversity among peoples and in nature (www.ArcusFoundation.org).